Co-organized by the Museum of Fine Arts of the School of Visual Arts & Dance at Florida State University and the University of Lethbridge Art Gallery of Alberta, Canada, with grant assistance from the Florida Arts Council, and the Youth International Internship Program, Department of Foreign Affairs and International Trade, Canada.

Jeffrey Spalding
Curator

Florida State University Museum of Fine Arts
February 18 - April 2, 2000

Appleton Museum of Art, Ocala, Florida
July 15 - October 29, 2000

ABCs of POP ART
AMERICA, BRITAIN, CANADA
MAJOR ARTISTS and THEIR LEGACY

PROJECT SUPPORT AND ORGANIZATION

ABCs of POP ART—America, Britain, Canada: Major Artists and Their Legacy was organized by the Florida State University Museum of Fine Arts in collaboration with the University of Lethbridge Art Gallery in Alberta, Canada. Curator: Jeffrey Spalding, Director, Appleton Museum of Art. Project Grantwriter / Editor—Allys Palladino-Craig; Appleton Coordinator—Jean Young; Museum Press Design / Fiscal Officer—Julienne T. Mason; Educational Programming—Viki D. Thompson Wylder; Chief Preparator—Mark Fletcher.

This program is sponsored in part by the State of Florida, Department of State,
Katherine Harris, Secretary of State,
Division of Cultural Affairs, and the
Florida Arts Council

The Museum gratefully acknowledges the support of the
Seven Days of Opening Nights

Educational Programming for K-12 and Seniors underwritten in part by grants from the
Communiversity Partnership—Tallahassee Cultural Services
and
The Tallahassee Junior Women's Club

Funding: Museum Press publication was supported by funding generated from private contributions and public grant funds raised for programming. Other Museum funding derives from the School of Visual Arts & Dance, J. L. Draper, Dean; fund-raising by the Museum on behalf of its programming includes the gratefully-acknowledged support of the Membership.

Museum Press

Editor / Publisher: A. Palladino-Craig
Graphic Design: Julienne T. Mason
Printer: Progressive, Jacksonville, Florida

CONTENTS

Cover: **Roy Lichtenstein** (American, 1923-1997), ***Sandwich and Soda (Lunch Counter)***, 1964, from the Wadsworth Atheneum portfolio: "X + X" - Ten Works by Ten Painters, color screenprint on acetate, 51/500, 20 x 24 inches. The University of Lethbridge Art Collections; British Gift 1983 (donor anonymous). Accession number: 1983.256 (John Dean Photographs, Inc., Calgary, Alberta, Canada.)

LENDERS TO THE EXHIBITION

University of Lethbridge Art Gallery, Lethbridge, Alberta, Canada
Graphicstudio, University of South Florida
Appleton Museum of Art, Ocala, Florida
Museum of Fine Arts, Florida State University

BENEFACTORS

The Florida Arts Council
Communiversity Partnership—Tallahassee Cultural Services
The Tallahassee Junior Women's Club
Seven Days of Opening Nights Festival

TALLAHASSEE *SEVEN DAYS OF OPENING NIGHTS* EXECUTIVE COMMITTEE

Margo Bindhardt, Chair

Bettie Barkdull
Talbot D'Alemberte
Grace Dansby
Jerry Draper
Ray Fielding
Michael M. Fields
Donald Foss
Bruce Halverson
Mart Hill
George Langford
Susan Mau
Steve Meisburg
Karen Moore
J. Michael Pate
Almena & Brooks Pettit
Jon Piersol
Michael & Kitty Powl
Charles Wright

ACKNOWLEDGMENTS

The *ABCs of Pop Art* is the inaugural event of the arts festival co-organized by Florida State University and the cultural community of Tallahassee. *Seven Days of Opening Nights* is now in its second year—with an executive committee comprised of cultural leaders in the regional community, the 'arts' Deans of Florida State, and the President of the University. It was a rousing success in its first season, and we look forward to its remaining an exciting feature of our annual calendar.

In the context of the festival, I have the pleasure of introducing Jeffrey Spalding, the new Director of the Appleton Museum of Art. Jeffrey has served as Curator of this year's Pop Art exhibition which has been created for the two museums of Florida State University: the Museum of Fine Arts in Tallahassee, and the Appleton Museum of Art in Ocala. As a man of immense energy and commitment, Spalding is simultaneously Co-director of Programmes at the Institute for Modern and Contemporary Art in Calgary, Alberta, and served as the former Director of the University of Lethbridge Art Gallery. The Curator's essay in this catalogue is particularly eloquent because the collection in Lethbridge, from which the exhibition works were drawn, was lovingly assembled by Jeffrey during his tenure there.

We extend our sincerest thanks to the University of Lethbridge Art Gallery, our co-organizing institution, and to our sponsors—the Canadian Consulate General of Atlanta and the Florida Arts Council, under the auspices of Secretary of State Katherine Harris. To all who played a part in the success of this project, bringing the *ABCs of Pop Art* to Florida, we most humbly extend our gratitude. We also take pride in acknowledging the assistance of the Youth International Internship Programme from whence internship support, underwritten by the Canadian Department of Foreign Affairs and International Trade, materialized in the capable and enthusiastic person of Tammy Izsak, our Spring 1999 intern.

At the University of Lethbridge, we would once again like to recognize the scrupulous efforts of Lucie Linhart, Registrar, Adrian Cooke, Chief Preparator, and Victoria Baster, Assistant Curator, the staff of the Art Gallery there, as well as administrator Fred Greene. We also offer warm thanks to museum intern Jamie Flower, formerly of the University of Lethbridge and currently a graduate student in the Florida State University Department of Art History. As the collaboration between our two universities burgeons, it becomes more and more difficult to determine who is from where: we hope to keep the balance of trade in trim—through shared academic excellence, at the very least.

On behalf of J. L. Draper, Dean of the School of Visual Arts and Dance at Florida State University, both the Museum of Fine Arts on the main campus and the Appleton Museum of Art in Ocala join in celebrating this stellar event of *Seven Days of Opening Nights 2000.*

Allys Palladino-Craig
Director

THE ABCs OF POP ART
Jeffrey Spalding

Just what is it about Pop Art that makes it so different, so appealing?

For over forty years, Pop Art has basked in the limelight of international critical and public affection. While the works of other art historically notable post-war movements languish in museum storage, Pop Art is continually brought before our attention. New exhibitions and publications abound presenting the icons of Pop. The art works by principal artists associated with Pop currently command staggering sums at auction and the movement is afforded considerable floor space in art museum permanent installations, particularly so in Europe. The works and words of Andy Warhol have filtered their way into widespread common usage by the broadest imaginable audience. Clearly one could argue that Lichtenstein, Hockney, Segal, Oldenburg, Dine, Rauschenberg, Wesselmann, Blake, Caulfield, Jones, Curnoe, Wieland and Baxter are amongst the most influential and famous American, British and Canadian artists of the 20th century. Often humorous, sometimes irritating, yet always entertaining, Pop has created a rich visual legacy, that continues to challenge and inspire audiences and artists alike.

One might reasonably assume that we are very well acquainted with the careers of the majority of the key artists associated with Pop. Surprisingly, this may not be the case. Many fine artists who made substantial early contributions to the evolution of the movement are to this day little known or under-appreciated. Likewise, we might expect that the wide array of survey texts and exhibitions exploring the movement would provide us with a fair preparation towards understanding the primary themes and concerns proffered by Pop. Yet, extraordinary individual works by central Pop luminaries seem to elude discussion and assessment within the customary broad parameters and textbook definitions. In part, my task in *The ABCs of Pop Art* is to attempt to find art historical homes for these various and sundry misfits and orphans.

In part the problem is that the very idea of Pop Art is just far too seductive. I have suggested elsewhere* that audiences have been captivated, charmed and bemused by the spirited spunky irreverence of the Pop credo. For four decades prior to Pop's debut, the art public was served a steady diet of art tempered by two world wars, the depression and the Korean War. Whether abstract or representational, psychological gloom, an ill-defined, dark and menacing threat pervaded a forlorn art steeped in self-pity, lugubrious earnestness, seriousness of purpose, and existential brooding. Awash in the new optimism of burgeoning prosperity, bolstered by bright new technological progress and

* "Little Life on the Praries: Pop Art, and the Comfort and Trauma of a Mediated Existence," *Soup to Nuts* (Spokane, Washington: Cheney Cowles Museum), 1998.

scientific invention, the art public was ready to cast aside the *geometry of fear*, in response to a more upbeat promise. British artist, Richard Hamilton, in 1957 first outlined the following set of characteristics and attitudes that remain associated with the movement. Pop is:

Popular
Transient
Expendable
Low Cost
Mass Produced
Young
Witty
Sexy
Gimmicky
Glamorous
Big Business

These words have served as rallying cry and yardstick to assess the efforts of aspirants to the new art. It may be of value to note that for Hamilton, his words were not an attempt to outline characteristics describing his then current work or that of his contemporaries. Instead, they were a call to action, an intended guide to inspire contemplated future production: a destined manifesto. This is a significant distinction. For the media and public perception, these trademark traits, together as a whole define Pop. The artists seem instead to have sampled from the list, some of their works embodying some but not all attributes. Subsequent works might address a differing melange, incorporating still other interests and attitudes.

The artists who have come to be gathered under the common banner, Pop Art, are involved in a wide variety of artistic aims and subjects. Marco Livingstone, author of many important volumes concerning the movement and its artists, warns of the limits of the usefulness of trying to define precisely what is meant by the term. "Pop, like most art historical labels is a convenience for critics and historians but an irrelevance and irritant for most of the artists to whom it is applied." Yet, the current literature concerning the movement repeatedly embraces certain stylistic, attitudinal distinctions that are believed to define those works that may be most properly associated with Pop. Gleaned from these various texts we can construct a picture of a prototypical Pop artwork, our own....

Tops of the Pops Topology

Pop Subject Matter:
* reflects everyday life
* prefers ordinary contemporary stories versus elevated Classical themes
* subjects concentrated heavily on mass-produced objects from our urban built environment

- is narrative, story, text or idea-based art
- subject matter is drawn from current events
- preference for mundane, non-heroic subjects
- rarely involves conventional subject matter: landscapes, cityscapes or the human figure
- images and themes appropriated and quoted as a literal quotation and representation of a pre-existing source that is immediately recognizable to most viewers

Pop Media:
- rejects traditional art materials and classic media: oil painting, etching, bronze-casting, carving
- use of non-art materials
- features the attributes of industrial surfaces, media and commercial art techniques

Pop Stylistic Preferences:
- rejects obvious expressiveness of application
- uses repeated images arranged in basic units and grids
- embraces decorativeness and unabashed formalism
- shows a predilection towards anonymity, mechanization
- works do not show evidence of *the hand* of the artist

Pop Attitudes:
- Pop Art identifies with popular culture, pop music, celebrity and mass entertainment
- embraces hedonism, light-hearted
- positive versus pessimistic
- humor, irony, satire versus seriousness of purpose
- avoids sentiment and melancholic longing for days gone by
- rejects notions of creation/invention integral for centuries to the evaluation of past art
- deadpan, emotional detachment, and the appearance of being non-judgmental, cool, impersonal or indifferent to the subjects or actions portrayed
- rejects the exaggerated emotionalism and cult of personality associated with Abstract Expressionism
- denigrates standard notions of invention, uniqueness, self-expression and emotive content
- viewed as callous, unfeeling, anti-sentimental
- Pop comments upon mass culture in ways different from previous generations. Whereas, the idealistic aims of Bauhaus high modernism strove to promote continual product improvement, inversely, the bohemian fifties Bop generation rejected and distrusted middle-class possessions and values. Pop artists are sceptical consumers/participants.
- Pop is prototypically concerned with urban, American experience

Certainly, some key Pop works evince many of these conditions. However, most only do so to a lesser degree. On balance, something unsatisfying, unconvincing remains if we attempt to use these

understandings and general characteristics as definitional requirements. The general picture doesn't align well with the actual experience of individual works. The list of attitudes lines up most usefully with aspects of works created primarily between 1961-65 by Roy Lichtenstein, Patrick Caulfield, Robert Indiana, Tom Wesselmann and in some elements, Andy Warhol, but not entirely. The primary concerns of George Segal, Edward Kienholz, Claes Oldenburg, Peter Blake, David Hockney, Marisol, Robert Rauschenberg, Jasper Johns and Jim Dine seem only vaguely alluded to. Equally unfortunate, these concepts color and limit our reception and assessment of the work of the accepted key figures across different time periods. Artists working outside America and Britain are customarily downplayed in presentations about Pop. For our exhibition, *The ABCs of Pop Art*, we have chosen to acknowledge a broader use of the term.

In 1959-1960, Claes Oldenburg, Tom Wesselmann, Jim Dine and George Segal among others regularly exhibited together as the *Judson Group* at the Judson Gallery of Judson Memorial Church, NY. These artists along with Robert Rauschenberg, Jasper Johns, Edward Kienholz, Marisol, Red Grooms, Arman, Louise Nevelson, Larry Rivers, were frequently grouped in countless exhibition combinations. However termed, all seemed to share one common *stylistic* bond. Rather than dedication to abstract art and the language of form, they all reasserted the primacy of subject matter, humanity and the human condition as the principal subject matter and concern of their work. However, the figurative art of the preceding decades tended to rely upon staged theatrical compositions, conventional studio-concocted scenes, heightened in color contrived to ensure emotional impact. Comparatively speaking, the New Realists appeared to present their subjects in the raw, without editorial comment. It would be the Pop artists who would embrace contemporary, lived experience as prime subject. Their work asserted that living *here and now* was the proper purview for art to investigate and chronicle. Contemporary experience need not be filtered through elevated high brow themes and studio-contrived compositions to add value to the subject under examination. A still life setting more properly could be found at the supermarket than by referencing Morandi; newspapers were the source of genre pictures, not academic compositions constructed through *life* drawing class. Their innovations changed the face of art. However, startlingly, it has had little appreciable impact upon the teaching conventions of art schools. Standard life drawing and studio compositional practices continue today in full force at the vast majority of art colleges world wide. Every New Realist artist had their own particular point of view upon this enterprise ranging from the humor of Lichtenstein to the irony and satire associated with Warhol and Wesselmann, to the sentiment and melancholic existentialism of Segal to the bitter, sometimes angry, social critique of Kienholz. This world-wide trend was showcased by the *International Exhibition of New Realists*, held in November 1962 at Sidney Janis Gallery, NY. Their work was fresh and seductive, following a countless variety of options, ranging amongst abstract figuration, collage, assemblage, and Neo-Dada. One month later, on December 13, 1962, The Museum of Modern Art held a Pop Art Symposium. The proceedings of the panel were transcribed and published in Arts Magazine. Soon thereafter the popular press seized upon the Pop phenomenon taking evident pleasure in the fact that its contentious nature rankled the cultural establishment. Many of the artists associated with end-of-

the-fifties New Realism maintained ties to artistic legacies born of Dada, Surrealism and expressive abstraction. A new delimited sub-category, Pop Art, was emerging within public perception as a brash audacious voice holding a non-conformist, oppositional stance; association with lofty cultural heritage was clearly a liability. It is during this relatively brief period between 1962-1965 that the majority of works were made which most closely resemble Hamilton's definitional model of Pop. Employing strategies of appropriation, Warhol and Lichtenstein's *lifted* imagery bespoke the nihilistic attitudes of Neo-Dada. By 1966, they, and most artists associated with Pop, had all but abandoned appropriated images in favor of creating their own photos, drawings or forms.

Subsequently, repeated exhibitions and publications have attempted to further prune down the term Pop Art to meet specific special interests. Many choose to associate Pop solely with a narrow group of artists obsessed with mass media, our optimistic recollection of the sixties and an attitude of iconoclastic irreverence. For some enthusiasts, geographic distinctions predominate. Pop has come to be inextricably linked with New York or is, at very least, quintessentially urban American. According to a recent Museum of Modern Art exhibition held at Atlanta's High Museum, Pop Art is a New York phenomenon. Under the simple banner, *Pop Art,* MOMA selected to showcase American artists that emphasised Pop's New York roots.

We can be thankful for the opportunities these exhibitions permit to see numbers of fabulous works. However, these limited, skewed art historical representations tend to artificially lend support to reinforce hierarchies of value, elevating the stock of some at the expense of others. Warhol, Rosenquist, Lichtenstein and Indiana are now commonly acknowledged as important *members of the set.* Pop Art. Other practitioners associated early on with the foundations of the movement become overlooked time and again. The qualities of their art become devalued; they don't appear to naturally fit in. This belies the nature of the actual organic working interrelationships amongst a generation of artists that were often exhibited together by virtue of perceived related values. Unlike the School of Paris, who often socialized and banded together to commiserate about shared artistic goals, most artists associated with the early evolution of Pop developed their artistic styles in geographic isolation from one another. They were brought together and introduced to each other's work after the fact by virtue of inclusion in exhibitions.

Declaring whether a work is, or is not, described within the bounds of art historical categories is necessarily loose and imprecise. However, particularly as it applies to Pop, the outcome of imposing, and later externally-applied criteria has most often removed a large number of interesting figures from public awareness and discussion. Despite the intensely active current interest in Pop, we are not often encouraged to become familiar with the range of artistic temperaments and concerns from across America and beyond. Our own exhibition, *The ABCs of Pop Art* brings together again artists from America, Britain and Canada that were identified at the time as integral players throughout Pop's formative years. Their interrelationships are based upon a spectrum of comparable interests. However, in the end, all the artists—whether American, British or Canadian—follow distinctive

individual artistic paths rather than a jointly-held aesthetic program. For this catalogue I have thereby shied away from recounting their efforts subsumed within a narrative outlining the regional development of Pop impulses within each of the three countries.

There exist a number of fine overviews of the international movement, particularly valuable is Lucy Lippard's excellent international survey Pop Art, and numerous publications and exhibition catalogues regarding the same by Marco Livingstone. To be recommended also is the book accompanying the exhibition, *The Independent Group: Postwar Britain and the Aesthetics of Plenty*; therein is a fascinating account which attempts to clarify the often exaggerated story of the impact of the Independent group upon the evolution of British Pop. In the *Soup to Nuts* essay, "Little Life on the Prairies: Pop Art, and the Comfort and Trauma of a Mediated Existence," I had ample opportunity to present a case for considering Pop artists within the context of continuity with classical humanist values.

The ABCs of Pop Art accepts its own internal limitations. Drawn primarily from one public collection, The University of Lethbridge, Alberta, Canada, it can not be encyclopædically inclusive. Their collection holds fine representative Pop examples from America; the strongest individual works are by British and Canadian exponents of the movement. Jasper Johns, the seminal figure in mid-fifties Proto-Pop, is not represented in the collection—nor are Rivers, Marisol or Nevelson; Rosenquist solely by work of the nineties. Similarly, the University's holdings of European New Realism and Neo-Dada are not as yet strong enough to make a significant contribution in support of an inclusive international overview. That story of the evolution of Pop would center upon artists such as Mimmo Rotella, Arman, Daniel Spoerri, Gerhard Richter, Sigmar Polke among others to provide a more objective picture of the unfolding of these artistic tendencies.

The ABCs of Pop Art presents the work of American, British and Canadian artists associated with the original and more inclusive set of Pop Art practices, initially termed New Realism. This broader view allows us to comprehend the range of expression explored by many of the key artists throughout their careers and to appreciate the larger impact of these artists and the movement upon subsequent and current generations of art makers. Few contemporary artists these days expend much effort appropriating consumer icons or comic-book drawings into their art. Pop's oblique, ironic commentary has generally given way in current practice to agit-prop interventions and direct, targeted social critique. The plethora of artistic styles pursued by the originators of Pop make it difficult to plot a cohesive path articulating their relationship with artistic progeny. Yet, Pop Art has empowered a variety of current responses as diverse and complex as the family of concerns investigated by its originators.

Jeffrey Spalding
Professor of Art
Director
The Appleton Museum of Art

Arman
Iain Baxter
David Buchan
Patrick Caulfield
Tony Cragg
Chris Cran
Jim Dine
Gathie Falk
Jenny Holzer
Allen Jones
Alex Katz
Roy Lichtenstein
Bruce McLean
Claes Oldenburg
Eduardo Paolozzi
Robert Rauschenburg
James Rosenquist
David Salle
George Segal
Wayne Thiebaud
Joe Tilson
Andy Warhol
Tom Wesselmann
Joyce Wieland

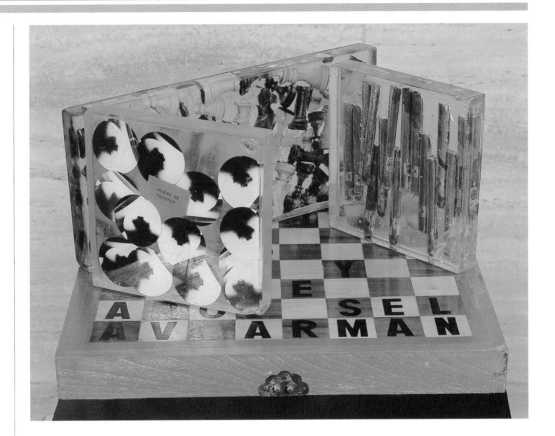

Arman (French-American, b. 1928), ***Homage to Duchamp —To and For Rose Selavy***, 1973, mixed media sculpture, ed. 69/90, 18 x 9 x 3.75 inches (box). The University of Lethbridge Art Collections; gift of Myrna and John Daniels, 1992. Accession Number: 1992.116 (Tammy Griffin Photography, Ocala, Florida.)

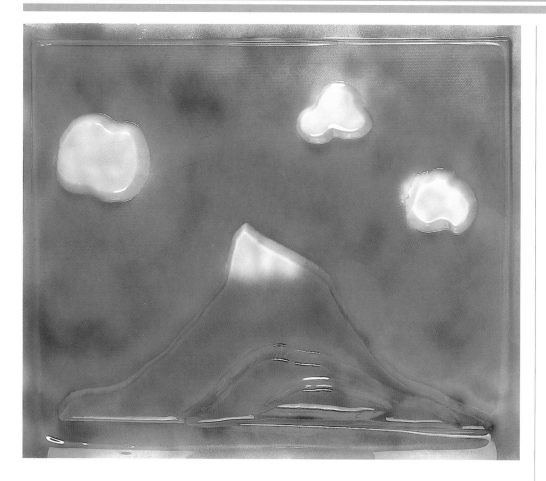

Iain Baxter (Canadian, b. 1936), **B.C. Landscape**, 1965, painted vacuformed plastic, 32 x 37.5 inches. The University of Lethbridge Art Collections; gift of Mr. Stanley Shapson, 1992. Accession number: 1992.278 (John Dean Photographs, Inc., Calgary, Alberta, Canada.)

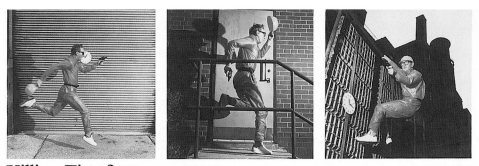

Killing Time? *Sixty seconds in a minute . . . sixty minutes in an hour . . . You know the rest of this story, but who knows where the time goes? Try and track it down, try and stop it in its tracks. You can beat the clock, but you can't kill time. The solution? Sit back and relax in* MODERN FASHIONS.

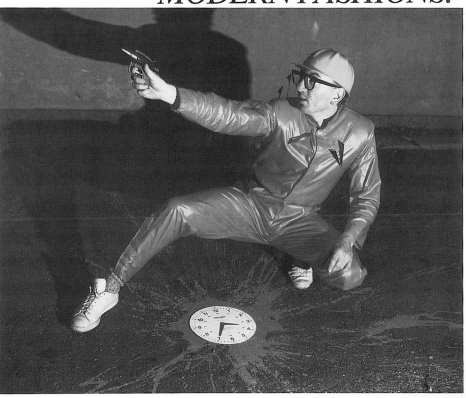

David Buchan (Canadian, 1950-1994), Photomural: *"Modern Fashions - Killing Time,"* 1979, 60.25 x 46.87 inches (153 x 119 cm). The University of Lethbridge Art Collections; gift of anonymous donor, Toronto, 1988. Accession number: 1988.254 (John Dean Photographs, Inc., Calgary, Alberta, Canada.)

D A V I D B U C H A N

Men like you like *Semantic* T-shirts!

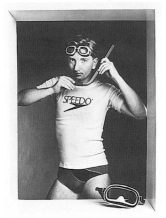

Going down? Perfect for all kinds of watersports. Get below the surface – get to the bottom of things in this outfit designed with total immersion in mind.

Tennis anyone? A bit of the old back-and-forth? In this dialogue with balls, it's not important who serves, but the quality of the exchange.

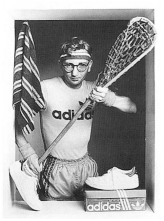

Our jocks are tops. Play ball, go for a long one, he shoots – he scores. Catch my drift? At any rate, in this game, it's three stripes and you're out.

This self-reflexive statement of the nature of compulsive self-identification in the latest style in self-addressing. His fetish, why the Semantic T-shirt!

Tell them who you are. When you've got something to say, don't just say it – wear it! No one likes to go unnoticed, and what better way of saying look at me than a sign. Logo Boys dancing to today's beat.

David Buchan (Canadian, 1950-1994), Photomural: ***"Modern Fashions - Men Like You Like Semantic T-shirts,"*** 1979, 60.25 x 46.87 inches (153 x 119 cm). The University of Lethbridge Art Collections; gift of anonymous donor, Toronto, 1988. Accession number: 1988.253 (John Dean Photographs, Inc., Calgary, Alberta, Canada.)

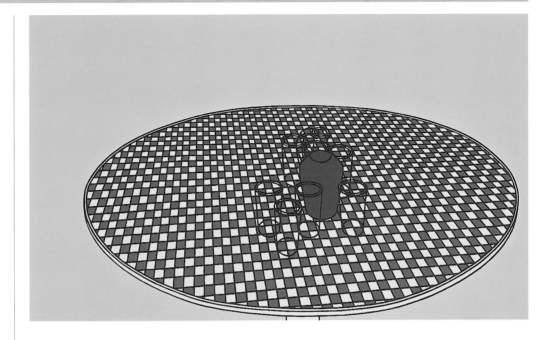

Patrick Caulfield (British, b. 1936), *Still Life on Checked Table*, 1968, oil on canvas, 36 x 60 inches. The University of Lethbridge Art Collections; purchase 1984 with funds provided by the Alberta 1980s Endowment Fund as a result of the British Gift (anonymous donor). Accession number: 1984.052 (John Dean Photographs, Inc., Calgary, Alberta, Canada.)

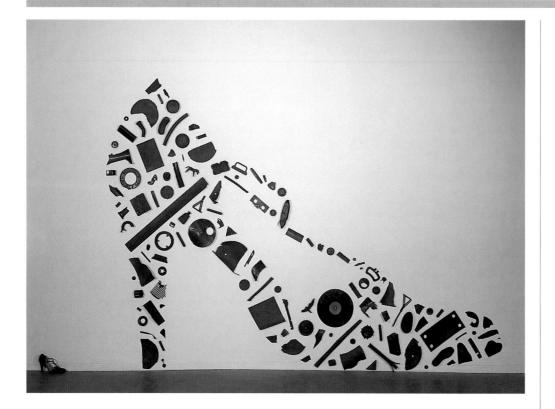

Tony Cragg (British, b. 1949), **Shoe**, 1983, black plastic found objects, shoe, 7 x 11 ft. installed. The University of Lethbridge Art Collections; purchase 1988 with funds provided from the Alberta Advanced Education Endowment and Incentive Fund. Accession number: 1988.091. Photography courtesy of the University of Lethbridge Art Galleries.

Chris Cran (Canadian, b. 1949), *Large Pink Laughing Man*, 1991, oil and acrylic on canvas, 274 x 183 cm. The University of Lethbridge Art Collections; gift of the artist, 1992. Accession number: 1992.335 (John Dean Photographs, Inc., Calgary, Alberta, Canada.)

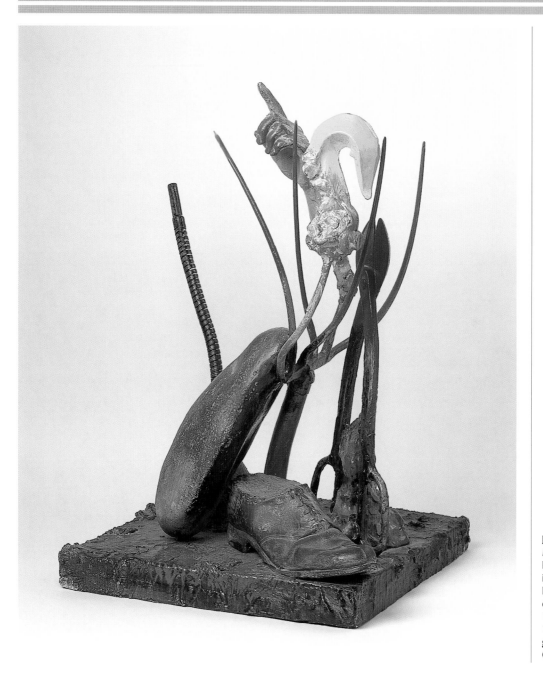

Jim Dine (American, b. 1936), *Pitchfork*, 1984, painted bronze, 1/6, 16 x 15.5 x 24 inches, The University of Lethbridge Art Collections; gift of an anonymous donor, 1998. Accession number: 1998.4 (John Dean Photographs, Inc., Calgary, Alberta, Canada.)

Jim Dine (American, b. 1936), **_Colorful Venus and Neptune_**, 1992, Color woodcut (diptych), 3/11, Panel 1: 67.12 x 37.12 inches; panel 2: 62 x 41.75 inches. The University of Lethbridge Art Collections; gift of an anonymous donor, 1998. Accession number: 1998.44 (John Dean Photographs, Inc., Calgary, Alberta, Canada.)

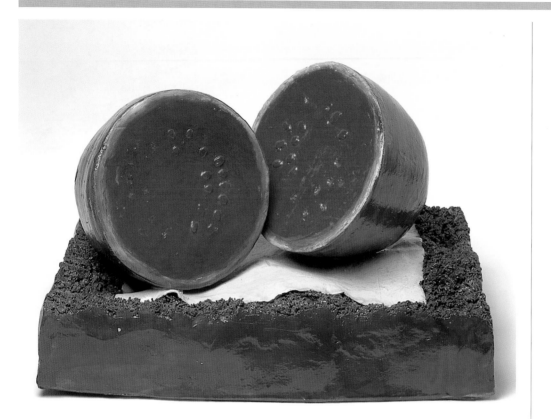

Gathie Falk (Canadian, b. 1928), *Picnic with Red Watermelon #1*, 1976, ceramic, 11 3/4 x 18 1/2 x 13 1/2 inches. The University of Lethbridge Art Collections; purchase 1997. Accession number: 1997.4 (John Dean Photographs, Inc., Calgary, Alberta, Canada.)

Jenny Holzer (American, b. 1951), Selected Text Sequences from **Truisms**, 1985, LED sign with red diodes, 4/5, 6 1/2 x 121 1/2 x 4 inches. The University of Lethbridge Art Collections; purchase 1988 with funds provided by the Alberta Advanced Education Endowment and Incentive Fund. Accession number: 1988.124 (John Dean Photographs, Inc., Calgary, Alberta, Canada.)

Allen Jones (British, b. 1937), *Clasp*, 1990, watercolor on paper, 30 x 22 inches. The University of Lethbridge Art Collections; gift of an anonymous donor, 1998. Accession number: 1998.18 (John Dean Photographs, Inc., Calgary, Alberta, Canada.)

Alex Katz (American, b. 1927), **Red Band**, 1979, screenprint 55/60, 55 x 36 inches. The University of Lethbridge Art Collections; purchase 1983. Accession Number: 1983.420 (John Dean Photographs, Inc., Calgary, Alberta, Canada.)

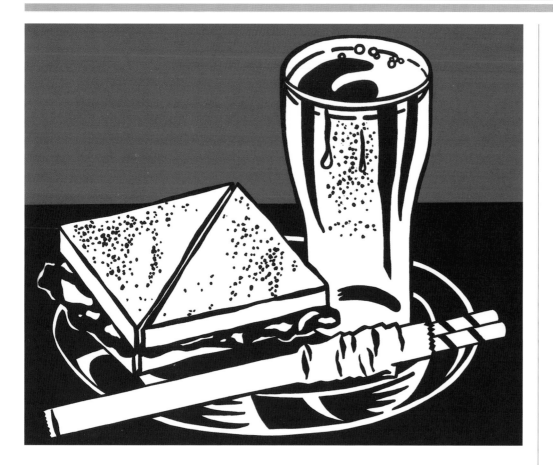

Roy Lichtenstein (American, 1923-1997), **_Sandwich and Soda (Lunch Counter)_**, 1964, from the Wadsworth Atheneum portfolio: "X + X" - Ten Works by Ten Painters, color screenprint on acetate, 51/500, 20 x 24 inches. The University of Lethbridge Art Collections; British Gift 1983 (donor anonymous). Accession number: 1983.256 (John Dean Photographs, Inc., Calgary, Alberta, Canada.)

Bruce McLean (Scottish, b. 1944), *Custom Built*, 1991, monotype on steel, 55 x 55 inches. The University of Lethbridge Art Collections; gift of Miriam Shiell, 1995. Accession number: 1995.113 (John Dean Photographs, Inc., Calgary, Alberta, Canada.)

Claes Oldenburg (American, b. 1925), *Soft Drum Set*, 1960/69, mixed media multiple, 47/200, 10 x 19 x 14 inches. The University of Lethbridge Art Collections; purchase 1986 with funds provided by the Province of Alberta Endowment Fund. Accession number: 1986.151 (John Dean Photographs, Inc., Calgary, Alberta, Canada.)

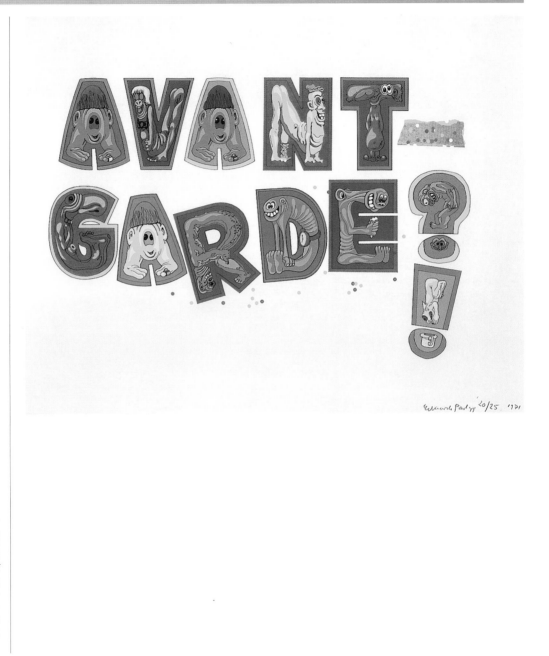

Eduardo Paolozzi (British, b. 1924), *Avant-Garde*, 1971, screenprint, 20/25, 23 x 30.5 inches (frame size: 32 x 40 inches). The University of Lethbridge Art Collections; British Gift (donor anonymous), 1983. Accession number: 1983.282 (John Dean Photographs, Inc., Calgary, Alberta, Canada.)

RAUSCHENBERG RTP 82

Robert Rauschenberg (American, b. 1925), *America Mix*, 1983, (1 print from a suite of 16), photogravure with chine colle, 20 x 26 inches (framed 28 x 36 inches each). The University of Lethbridge Art Collections; gift of Gary M. Gray, 1993. Accession number: 1993.450 (tba). (John Dean Photographs, Inc., Calgary, Alberta, Canada.)

Robert Rauschenberg (American, b. 1925), ***America Mix***, 1983, (3 prints from a suite of 16), photogravure with chine colle, 20 x 26 inches (framed 28 x 36 inches each). The University of Lethbridge Art Collections; gift of Gary M. Gray, 1993. Accession number: 1993.450 (tba). (John Dean Photographs, Inc., Calgary, Alberta, Canada.)

James Rosenquist, (American, b. 1933), **The Kabuki Blushes**, 1986, lithograph/monoprint, 39 x 41 1/2 inches. Collection: Graphicstudio. Printed at Graphicstudio, University of South Florida; photograph courtesy of Graphicstudio.

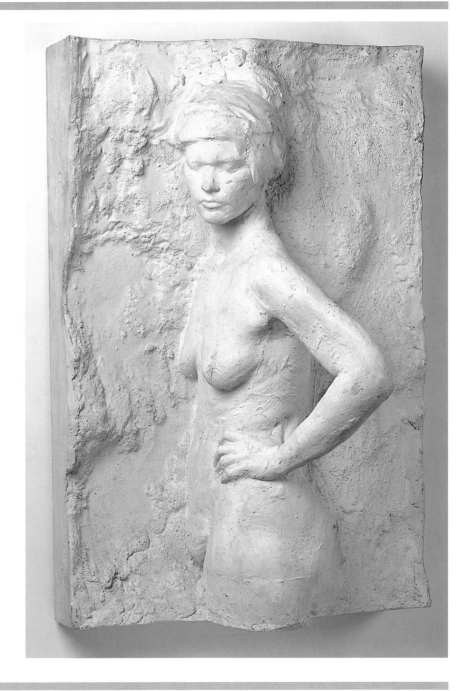

George Segal (American, b. 1924), *Naked Girl*, 1978, plaster, 41 1/2 x 28 1/2 x 22 1/2 inches. The University of Lethbridge Art Collections; purchase 1991 as a result of a gift from Dr. Roloff Beny. Accession number: 1991.011 (John Dean Photographs, Inc., Calgary, Alberta, Canada.)

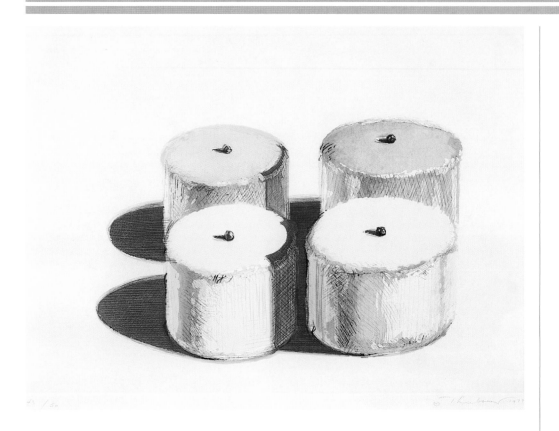

Wayne Thiebaud (American, b. 1920), *Four Cakes*, 1979, etching/aquatint, 43/50, 22 1/2 x 29 3/4 inches (paper). The University of Lethbridge Art Collections; purchase 1988 with funds provided by the Alberta Advanced Education Endowment and Incentive Fund. Accession number: 1988.020 (John Dean Photographs, Inc., Calgary, Alberta, Canada.)

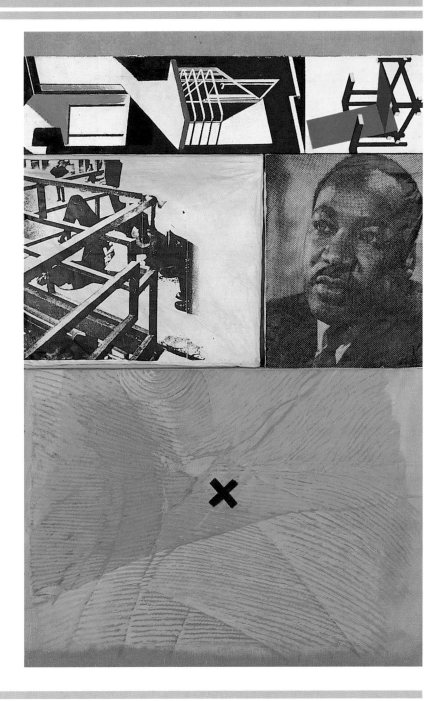

Joe Tilson (British, b. 1928), **_Martin Luther King_**, 1969, relief, screen and oil on canvas and wood, 176.7 cm x 125.7 cm. Collection: Appleton Museum of Art, Ocala, Florida. (Tammy Griffin Photography, Ocala, Florida.)

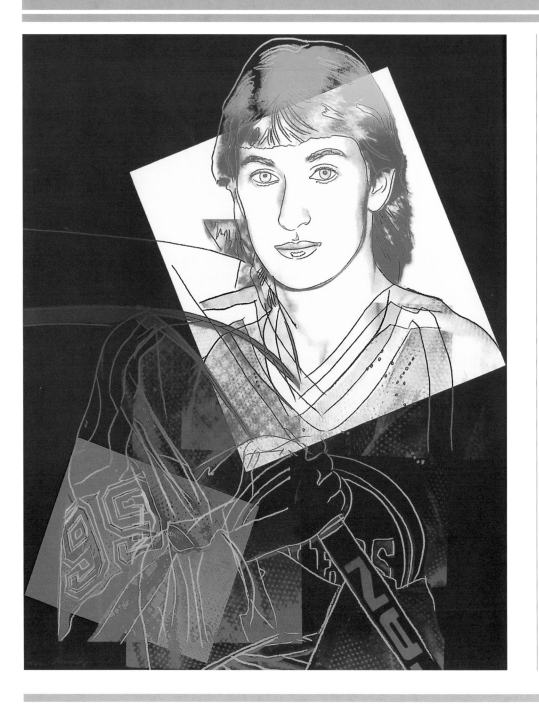

Andy Warhol (American, 1928-1987), **Wayne Gretzky 99**, 1982, screenprint, 133/300, 39 1/2 x 31 1/4 inches. The University of Lethbridge Art Collections; gift of Mr. J. Derek Cook, Richmond, B.C., 1986. Accession number: 1986.227 (John Dean Photographs, Inc., Calgary, Alberta, Canada.)

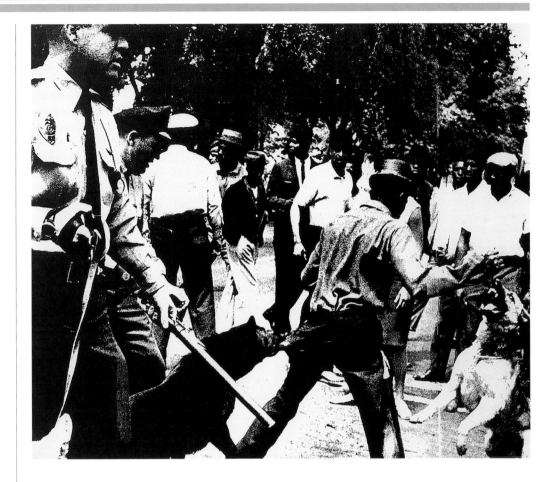

Andy Warhol (American, 1928-1987), **Birmingham Race Riot**, 1964, screenprint, 51/500, 20 x 24 inches. The University of Lethbridge Art Collections; British Gift 1983 (donor anonymous). Accession number: 1983.359 (John Dean Photographs, Inc., Calgary, Alberta, Canada.)

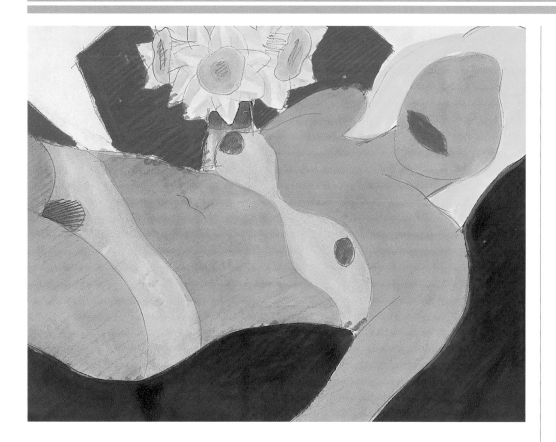

Tom Wesselmann (American, b. 1931), ***Great American Nude***, 1967, mixed media on paper, 7 x 9 inches. The University of Lethbridge Art Collections; purchase 1988 as a result of a gift from Mr. J. Derek Cooke, Richmond, B.C., 1986. Accession number: 1988.281 (John Dean Photographs, Inc., Calgary, Alberta, Canada.)

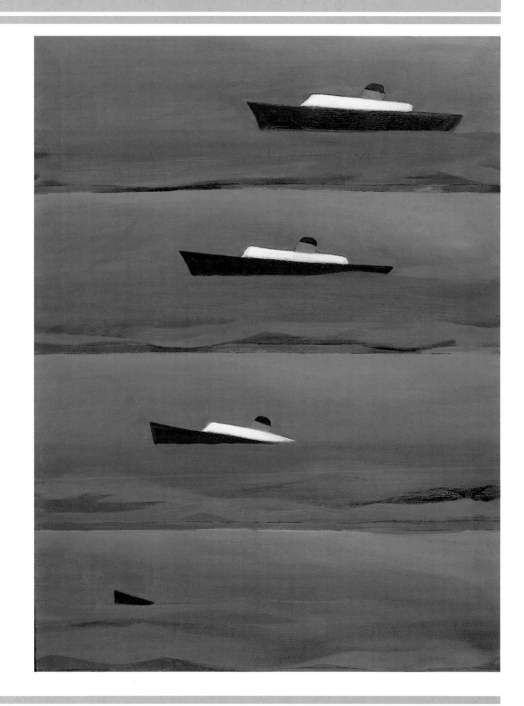

Joyce Wieland (Canadian, 1931-1998), ***Untitled (sinking liner)***, c. 1963, oil on canvas, 32 x 24 1/8 inches. The University of Lethbridge Art Collections; purchase 1985 with funds provided by the Province of Alberta Endowment Fund. Accession number: 1985.028 (John Dean Photographs, Inc., Calgary, Alberta, Canada.)

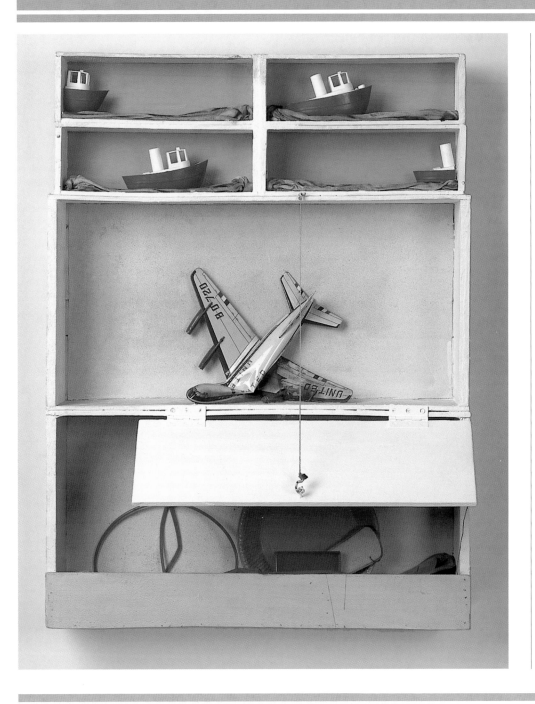

Joyce Wieland (Canadian, 1931-1998), ***Cooling Room No. I***, 1964, painted construction in plexiglas box 38 x 31 1/2 x 11 1/2 inches. The University of Lethbridge Art Collections; gift of Vivian and David Campbell, Toronto, 1989. Accession number: 1989.036 (John Dean Photographs, Inc., Calgary, Alberta, Canada.)

AMERICAN POP

Arman
Chuck Close
Jim Dine
Richard Estes
David Gilhooly
Jenny Holzer
Robert Indiana
Alex Katz
Roy Lichtenstein
Claes Oldenburg
Robert Rauschenberg
David Salle
George Segal
Wayne Thiebaud
Andy Warhol
Tom Wesselmann

BRITISH POP

Peter Blake
Patrick Caulfield
Tony Cragg
Michael Craig-Martin
Richard Hamilton
David Hockney
Allen Jones
R.B. Kitaj
John Latham
Bruce McLean
Eduardo Paolozzi
Peter Phillips
Joe Tilson

CANADIAN POP

Iain Baxter
David Buchan
Dennis Burton
Chris Cran
Greg Curnoe
Gathie Falk
Attila Richard Lukacs
Michael Snow
Tony Urquhart
Joyce Wieland
John Will
Russell Yuristy

The following biographical entries were researched and prepared by Tammy Izsak, Curatorial intern, The University of Lethbridge. Most of the entries have been considerably expanded through contributions and additions from Jeffrey Spalding, Director of the Appleton Museum of Art and members of the University of Lethbridge Art Gallery staff, especially Victoria Baster, Assistant Curator, and Ryan Doherty, Curatorial Assistant.

AMERICAN POP

ARMAN
French, b.1928

Born in Nice, as Armand Fernandez, Arman has become an important figure in both France and the United States, dividing his time between New York, Paris and Nice. Like Vincent Van Gogh, he dropped his last name, later discarding the "d" in his first name, inspired by a typographical error. Originally intending to follow his father's profession in antiques, he studied Archeology and Oriental Art at the École Nationale des Arts Décoratifs in Nice and at the École de Louvre in Paris. While attending judo classes in 1948, he met Claude Pascal and Yves Klein, who became a close friend and collaborator, the two later exhibiting as founding members of the French *nouveau réalisme* group in 1960. Arman is an artist of *accumulations*, whether that be markings from rubber stamps (*cachets*), impressions of dipped objects (*allures d'objects*), or collections of trash (*poubelles*). His work consistently addresses the cycle of production and consumption. He is best known for his accumulations of objects—assemblages created from sliced or burnt instruments, paint tubes and paint embedded in plexiglass, and sculptural pieces created from the repetition of common industrial products, like Renault fenders or car door switches.

Homage à Duchamp, presents a veritable slice of life; a coy erotic play in keeping with the spirit of the master. Arman's accumulations present a contemporary means to approach the conventional format of the still life. Akin to Duchamp's ready-mades, rather than create or draw the objects, Arman simply gathers and represents the items. Suspended in time, these cultural fragments accrue a more exotic appearance with each passing year. What were once customary, standard off-the-shelf items are transformed through passage of time. The product types, packaging, and so forth evolve—rendering uniqueness to the encased, atypical, unfamiliar product.

CHUCK CLOSE
American, b. 1940

Receiving his first paint set and easel at age five, Close's path to becoming an artist began early in life. At age thirteen, he became enraged on first viewing a painting by Jackson Pollock, then returned home to drip paint across his canvases. Intending to work as a commercial artist, Close attended Everett Junior College, then transferred to the University of Washington in Seattle in 1960. Inspired by the work of Jasper Johns, in 1961 he cut up the American flag, then sewed it into the shape of a mushroom cloud: a work which won him third prize at the Seattle Art Museum before being thrown out of the show. In 1963, Close received his BFA from Yale, where he studied with fellow classmates: Michael Craig-Martin, Richard Serra, Nancy Graves, Janet Fish, and studied under Robert Rauschenberg, Frank Stella and Richard Lindner. He received his MFA the following year. In 1967 he painted a black and white 21-foot nude female figure on canvas, based on black and white photos he had taken earlier. Though he did not return to the full-figured nude, this signaled the beginning of Close's large scale portraits for which he is so well known.

Often seen as a photo-realist painter, Close's portraits emerge from a strong Modernist environment. His main concerns dwell primarily on the process of art-making and the nature of the materials used: the figure is chosen for its formal qualities rather than for its personal meaning. Many of his portraits resemble unflattering mug-shots or ID photos—the utilitarian images extracted from life. Over the past thirty years, Close has taken these images through a series of explorations using a variety of media. His works have employed: black and white images using the airbrush, rags, and brushes, a color series using a three-color process akin to that of color printing; mezzotint and grid processes; airbrushed "dot" drawings; lithography; pastels; etching; fingerprint drawings; Polaroid photographs; pulp-paper collage; fingerprint painting; fingerprint etching and spitbite aquatints. In 1988, Close was stricken with incomplete quadriplegia which initially left him paralyzed from the neck down. After spending six weeks in intensive care he was transferred to another hospital for rehabilitation where he continued to paint. He returned home July 1989.

Close's recent work evokes a more impressionistic sense, continuing his exploration into the large grided surface, but painting within these grid blocks vibrant, abstract areas of color. Exhibiting his work worldwide, he is perhaps one of the most

famous contemporary American painters today. His large-scale portraits are often associated with the legacy of Pop Art. They share some related compositional strategies, attitudes and techniques. Close pictures his sitters with a characteristic deadpan, matter of fact, frontal presentation uninflected by expression. Although he does not strive to pose his sitters to bring out their personality or character, this emerges nonetheless. Like Arman, Close chooses to preserve a fragment of reality without editorial comment. Over time, they too appear to give forth the inflection of periodicity.

The works are transformed from their initial photo source through alteration in scale and the expending of massive amounts of human labor. Initially his technique seemed to replicate the appearance of the photo, challenging our sense of why we might value a laboriously constructed hand-made version of a photo blow-up. Increasingly viewers are aware of the stylization and simplifications that the artist has had to make to render the likeness. In more recent works the depiction is a conspiracy of elaborate expressive strategies which nonetheless fuse to replicate the image. In these works perhaps Close has come to grips with his early nemesis, Jackson Pollock; these works seem contrived to create swirling patterns of all-over mark-making, punning the surface treatment so characteristic of Pollock's Abstract Expressionism.

JIM DINE American, b.1936

> "I think the biggest inaccuracies that have been written about me have to do with Pop art and my relationship to it. There's been no real understanding of my strange voyage in art. By lumping me in that way, you view the work differently."
>
> —Jim Dine;1986 interview with Marco Livingstone

Since his emergence in late 1950, Jim Dine's work has been expressed through a diversity of media including sculpture, painting, printmaking, assemblage and happenings. Born in Cincinnati, Ohio, Dine studied fine art at the University of Cincinnati, the Boston School of Fine and Applied Arts, and Ohio University, graduating in 1957. In 1958 he moved to New York where his mixed-media constructions and experimentation with "happenings" quickly earned him a reputation as an exceptional young talent. Beginning in February 1959, he became one of the principal members of the Judson Group, a group of artists who exhibited frequently together at Judson Gallery of Judson Memorial Church, New York. Other key group members were: Claes Oldenburg, Tom Wesselmann and George Segal. In 1959 Dine incorporated real objects into his work in assemblages and as subjects for paintings and prints. Among his varied subjects are the specific motifs of clothing—such as the bathrobe—as a reference to the self; tools, as extensions of the hand and symbols of artistic creation; and more recently, the iconography of the heart and art historical references such as the *Venus de Milo*. With objects both commonplace and personal, both poetic and ironic, Dine reflects on his own feelings about life, centering on the question of what it means to be human.

Many of his motifs reflect his boyhood pleasure working at his father's commercial paint and plumbing-supply store and in his grandfather's hardware store. These formative experiences are often listed as a causative link to Dine's subject matter—the simple implements and hand-tools created as cultural icons within Dine's work of the early sixties. More recently he created a series of sculptures based upon these tools. *Pitchfork* 1984, a hand-painted bronze, edition 1 of 6, is a superlative example of these works; it gathers together many of the cast of characters as subject/symbols that recur continually within Dine's work. From this striking work important further comparison may be drawn with the ordinary objects, found-art neo-Dada expressions of single contemporary objects associated with late-fifties, mid-sixties Pop Art such as Jasper Johns' Ballantine Ale cans, Joe Tilson's *Two Wristwatches* 1965 (University of Lethbridge), works by Andy Warhol, Lichtenstein, Wesselmann, and Iain Baxter's *product portraits*.

This stylistic aspect is well known internationally. It also has had numerous idiosyncratic western Canadian offshoots, especially associated with Regina ceramic sculpture: among others Russel Yuristy's *Pilsner Beer,* but most notably works by Vic Cicansky. Unquestionably, the example of Dine's painted bronze implements has some bearing upon the discussion of the patinated and colored bronze work which has arisen amongst western Canadian artists—notably Joe Fafard and particularly Doug Bentham—and Vic Cicansky's garden tool sculptures.

Collaborating with Claes Oldenburg in New York, 1960, Dine staged his first *happenings,* profoundly influencing American Pop Art for the following two decades. In just four short years Dine would quickly become a star of the New York

art scene. His work was exhibited alongside artists such as Claes Oldenburg, Roy Lichtenstein, Jasper Johns, Robert Rauschenberg, Arman and Andy Warhol in the seminal 1962 exhibition which signalled the emergence of *Pop* Art, the *International Exhibition of New Realists* at the Sidney Janis Gallery, New York. However, included in the New Realists show were an assortment of works that were cool, witty, anti-expressive, and glamorous; the major players—Warhol, Lichtenstein and Wesselmann. The public embrace of this sub-group was immediate and overwhelmingly positive. As a result, many key artists central to the previous shared group aesthetic were cast into art historical limbo, referred to thereafter as *pre* or *proto-Pop*. The public reaction to the work of Jim Dine has regrettably suffered through this confusion. Some become frustrated looking for Pop Art attributes and attitudes when looking at the work of Dine, or for that matter Warhol and Lichtenstein. Perhaps there always were more important, evident clues about the primary motives of their work. Dine presents us with a parade of images, symbols and themes derived from classical art, antiquity and literature. It may be that it is to these sources that we might look to learn of Dine's message of mortality and humanity. Dine's work was presented at the Venice Biennale in 1964 and he has since taught at Cornell University in New York. His subjects are rich in art historical reference, re-claimed as his own through devices of repetition and alteration.

Many of Dine's prints are made using multiple media and techniques involving copper plates and wood blocks. The plates were created using several etching techniques such as spitbite, softground, and drypoint. Often Dine's marks are made utilizing power tools. The wood blocks were both hand-cut and created by *heliorelief*, a very unique and complex photo-emulsion process developed by Deli Sacilotto, Master Printer at Graphicstudio, a fine art print making shop at University of South Florida. In addition to these processes, Dine often hand-painted areas of his prints, creating an increased sense of light, touch, and of the personal. What is crucial here is the interplay between the distinctive surfaces, which coalesce to establish the drama of the work. Through his combination of forceful, energetic, expressionistic lines against dreamy, atmospheric background texture, Dine creates a powerful mix of media as a response to modern experience.

DAVID GILHOOLY
American, b.1943

The king of "Funk," David Gilhooly's ceramic, and later, plastic sculptures fuse the functionality and age-old tradition of ceramics with modernist history and the humor of popular icons. Born in Auburn, California, Gilhooly received his BA in 1965 and MA in 1967 from the University of California. During this time he worked with a number of artists whose work would soon be called "Nut Art" or California "funk." After a few initial shows, in 1966 Gilhooly placed work in the FUNK show, quickly followed by his career-launching solo show at the Museum of Modern Art in New York. Highly influenced by the Pop sculptures of Claes Oldenberg, Gilhooly began to create ceramic versions of fastfood and ice cream sundaes. Looking further into popular imagery, Gilhooly drew subjects from cartoon-like imagery, including a series of sculptures, bowls, incense burners and vases sporting frogs enacting different scenes, or posing as well-known historical and political figures. In the mid-eighties he branched into lithography and plastics. His experimentation with plastics enabled him to expand into a new realm of two and three dimensions, while exploring its versatile qualities and bold, electrifying colors. In his most recent work he continues to play with the varied subjects of personal and popular iconography, and art history, while, in many cases slipping serious political and social comments in amongst the humor. Gilhooly's work has been exhibited internationally. He has held a number of teaching positions in the United States, and has served as a sculpture and ceramics professor in Canada at the University of Regina, in Regina, Saskatchewan, where he inspired emerging Canadian artists such as David Thauberger.

JENNY HOLZER
American, b.1950

New York Conceptual artist, Jenny Holzer, emerged in 1978 with a series of texts entitled "Truisms." Holzer is the natural heir to Pop Art's mantle. Her work, like classic Pop, investigates mass media and its impact upon us. Initially, Holzer's interventions occurred in the street rather than in art galleries. Seen there, her LED signs would be all but indistinguishable from other institutionally-sanctioned advertisements found upon the facade of New York City buildings. *Truisms* delivers a series of short statements, some of which seem mundane, unobtrusive, while others are wacky and immoderate. The strength of the format Holzer selected is that her sign is not immediately identifiable as an artistic intervention. Protocol and decorum do not inhibit the messages on Holzer's signs; we are left trying to imagine how these personal musings have slipped through the cracks of an overseeing authority. Their quiet anarchy thrills us even while some of the specific messages are most unsettling.

As an artist, Holzer abandoned traditional techniques, turning instead to language as her principle means of expression. Her art is located between the realms of writing and the visual arts. According to Holzer, she, the artist, acts as a "universal

voice." Her texts are presented in a form accessible to the public at large, subversive and interventionary, destabilizing the imagery and vocabulary of various information sectors. Holzer produced of number of series following *Truisms: Inflammatory Essays* (1979-82); *Living* (1981-82), in collaboration with American painter Peter Nadin; *Survival Series* (1983), with texts on adhesive signs and metal supports; and *Under a Rock* (1986), which included gold lettering on architectural constructions reminiscent of funeral monuments. In 1987 Holzer produced films and books based on her texts. In 1993 she branched further into the realm of multimedia with her installation *Lustmord* (German for Sex-Murder). This installation was comprised of a cave-like structure sporting large LED signs, the interior of which was upholstered in red leather, covered with hand tooled text. While stretching the testimonial powers of language in the visual arts, many of her works have also explored themes of mortality/immortality, and social violence, for example, rape. She received a BFA from Ohio University in 1972 and an MFA from Rhode Island School of Design in Providence. Her work has been exhibited around the globe.

ROBERT INDIANA
American, b.1928

Born Robert Clark, in New Castle, Indiana, the Artist changed his last name to that of his native state to reflect his desire to capture the experience of modern America in his work. Indiana studied at a number of schools including the Art Institute of Chicago, Skowhegan School of Painting and Sculpture in Maine, the Edinburgh College of Art and London University in Britain. Moving to New York in 1954, Indiana was influenced by neighboring artists Ellsworth Kelly, Jack Youngerman, Agnes Martin and future Pop artist James Rosenquist. His early work consisted of sculpture assemblages and he later produced paintings with vivid color surfaces involving letters, words and numbers, exhibiting the minimal appearance of signs and commercial imagery. He produced several series with specific themes, including the number five, inspired from Charles Demuth's *I Saw the Figure Five in Gold* (1928); and a series based on the word 'Love' which embodied an idealistic philosophy of the era.

ALEX KATZ
American, b.1927

Alex Katz has been a prominent American artist since the 1950s. Known for his iconic portraits that have become icons of modern American life, his representational paintings reflect the formal concerns of sixties shape painting, Abstract Expressionism and Pop Art. Katz's relationship with Pop is peripheral. Like Wesselmann and Lichtenstein, Katz was an early exponent of the techniques of the billboard sign painter utilized in his figurative compositions. His works are often over-sized, reminiscent of billboard-scale. His representations are constructed using large areas of unmodulated flat color. The impression of light and shadow are created by abutting two areas of tone, rather than meticulously shading and rendering. Enthusiasts of his work revel in the simple economical way that Katz can render the human form with this spare technique. Despite his employment of this commercial art *shortcut*, his portraits are neither mechanistic, nor ironic. They exude warmth and genuine affection for the sitter (often his wife). Emphasis upon building compositions using flat areas of color also allows the artist to indulge his love of subtle, complex color combinations. He is a master colorist whose natural affinity is with the heritage of Matisse, Dufy and Fauvist French color.

From 1946 to 1949, Katz studied at the Cooper Union School of Art in New York with fellow Pop artists Robert Indiana and R.B. Kitaj. He then spent one year at the Skowhegan School of Painting and Sculpture in Skowhegan, Maine. Though his work partakes of many of the formal concerns shared by larger movements, Katz's work remains distinct as he modifies and builds upon these interests to meet his own personal needs.

ROY LICHTENSTEIN
American, 1923-1997

Lichtenstein began his career as a commercial artist and freelance designer. He studied at the Art Students League in New York and then received his MA from Ohio State University in 1951. In the late '50s, Lichtenstein's work passed through an Abstract Expressionist phase where he began to insert hidden references to Disney characters within his paintings. In 1960 a colleague introduced Lichtenstein to *happenings* and to the artists Jim Dine, Claes Oldenberg, and George Segal. The following year he created his first Pop paintings, transferring cartoon characters from comic books or bubble gum wrappers directly onto primed canvas with minor but telling changes. His brazen use of bold outline, primary colors and speech bubbles, and his imitation of the printing technique of Benday dots, caused a mixture of excitement and shock when the paintings were first shown at the Leo Castelli Gallery, New York, in 1962.

The work of Warhol, Lichtenstein and Wesselmann seemed to personify a new spirit of the times. Their work captivated

the public, the media and art museums. Their impact and success was meteoric. Many writers were captivated by the playful, spunky irreverent side of Pop, the fascination with current events of our time, subjects appropriated from the products of contemporary life, labels, magazines, pop culture and the mass media. Pop Art, to many, became conflated with this form of urban, chic, satirical critique. These impish acts challenged the values customarily attributed to art by virtue of traditional artistic skill; the gifted draughtsman and insightful inventor of new visual ideas and cultural signs. Their work seemed related to the neo-Dada assisted ready-mades of Marcel Duchamp.

Lichtenstein's *Sandwich and Soda* may for all intents and purposes appear to be a simple re-quotation of an advertising image. However, the artist profoundly restructures the images, refining shapes, patterns, simplifying and eliminating detail, changing the color and material properties for dramatic effect. This exquisite print from the portfolio X + X (Ten Works by Ten Painters) is printed on clear acetate. Like other Pop artists of the day, Lichtenstein was enthralled by *modern* materials. It is interesting to note, however, that these stylistic characteristics of Warhol and Lichtenstein occurred only briefly in their work, primarily 1961-65. Both artists stopped *lifting* images taken from other pre-existing sources after 1964; likewise text drops out of their work almost completely after 1965. Thereafter, Lichtenstein hand-drew his own images, often making reference to well-known cultural icons. Likewise, Warhol began to take his own Polaroid pictures of subjects which he would select, photograph, crop, adjust and hand-color, such as *Gretzy* and *Karen Kain*. In the '70s Lichtenstein produced a series of pictures parodying other painting styles such as Fauvism, Surrealism, etc. He has also retained his bold style and mechanical technique of reinterpreting images, but has adapted it for use with sculptures and murals.

CLAES OLDENBURG American, b.1925

Born in Stockholm, Claes Oldenburg arrived in Chicago as a child in 1936. After studying art and literature at Yale University, Oldenburg worked at the Chicago News Bureau as a trainee reporter while attending the Art Institute of Chicago at night. His move to New York in 1956 brought him in contact with artists Red Grooms, Jim Dine, and Alan Kaprow. He took part in *happenings* centered upon the Judson Gallery, and in 1958-59, began to create first assemblages of plaster and garbage soaked in striking colors. His assemblages soon led to the construction of environments, composed of similar yet smaller plaster sculptures and found items. With *The Store*, 1961, Oldenburg blurred the line between art and commerce by displaying his wares, mainly food and clothing, in a rented shop front and encouraging purchasers to take works away with them. At this time he also began to produce replicas of food like hamburgers, ice-cream and cakes, which prepared the ground for his over-size soft sculptures of fast food. They first appeared in 1962 at the Green Gallery in New York and throughout the early sixties at the Jerrold Morris International Gallery, Toronto. The Art Gallery of Ontario acquired their major Oldenburg sculpture, the giant hamburger from the Morris Gallery exhibitions. Since then, Oldenburg has fabricated different versions of household furniture, appliances and edibles: *hard* versions in painted wood, *soft* versions in cloth or vinyl, and *ghost* versions drained of the original color. A customary methodology for Oldenburg is to create drawings as proposals for monumental sculptures of everyday objects to be placed within architectural settings.

ROBERT RAUSCHENBERG American, b.1925

One of the most influential artists of post-war America, Robert Rauschenberg helped revolutionize post-Abstract Expressionist art in the US. After briefly studying pharmacology at the University of Texas and serving in the US Navy during World War II, Rauschenberg first studied at the Kansas City Art Institute. He attended the Académie Julian in Paris in 1948 and in 1949 studied under Joseph Albers at Black Mountain College, North Carolina. There he met choreographer Merce Cunningham, composer John Cage, and artist Cy Twombly and participated in the first *happening*. After moving to New York in 1949, Rauschenberg attended the Art Students League and did window displays for Bonwit Teller and Tiffany. In the 1950s he produced his first *combines*, influenced by Kurt Schwitters and the Cubist use of collage. In his attempt to "act in the gap between art and life," Rauschenberg's *combines* managed to merge two disparate worlds: the self-conscious, introspective realm of Abstract Expressionism with that of Pop Art's exploration and adulation of the outside world. His most renowned combines are *Rebus* (1955), *Monogram* (1955) and *Bed* (1955). In each, he combined everyday objects with elements of painting, often referencing Abstract Expressionist tendencies such as sweeps and runs of paint. It was during this time that Rauschenberg moved into a studio next to Jasper Johns. In 1962, he first used the technique of silkscreen on canvas, mixed with painting, collage, and affixed objects. He also completed his first lithographic work and first dance performance, *Pelican*, that year. He has won a number of awards and has received two honorary degrees: a doctorate from Grinnel College,

Iowa, and an Honorary Degree of Fine Arts, which he received with James Rosenquist from the University of South Florida, Tampa. In 1970 Rauschenberg set up the foundation *Change Inc.* for destitute artists and a house with art studios in Florida in 1971. He divides his time between his homes in New York City and on Captiva Island, Florida.

DAVID SALLE
<div style="text-align:right">American, b.1952</div>

Born in Norman, Oklahoma, David Salle received his BFA and MFA from California Institute of Arts before moving to New York where has lived and worked ever since. Drawing from images taken from his surroundings—his immediate world, the media, and his dreams—Salle's technique of superimposing these images in transparent or semi-transparent layers, imbues his compositions with a sense of energy. In 1982, he more aggressively broke up the picture plane, creating a further tension between his images as each retained its autonomy despite the juxtaposition. Through Salle's varied combinations of color and significant form, his work often wavers between the realms of figuration and abstraction. In the following decade, Salle branched into different media, including photography. In 1990 he exhibited a series of black and white photographs of female nudes. Four years later he exhibited sculpture for the first time, and in 1995 produced his first commercial film entitled *Search and Destroy.*

GEORGE SEGAL
<div style="text-align:right">American, b.1924</div>

George Segal is best known for his plaster sculptures cast directly from live models by wrapping the figures in medical bandages dipped in plaster. He placed many of his sculptural figures within environments portraying banal events of modern life, some including more intimate, usually private activities such as bathing or dressing. The emotional engagement evident in Segal's work distinguishes it from mainstream Pop Art, though his use of modern 'found' subjects does relate him obliquely to the movement. Segal took a foundation art course at Cooper Union in New York (1941-42) and studied a number of subjects part-time at Rutgers University, New Brunswick, New Jersey (1942-46), followed by a similar course at New York University (1948-49). Although he continued until 1958 to operate a chicken farm, he had been painting seriously since 1943. In 1958 Segal produced his first plaster sculptures, experimenting with plaster, wire and burlap to create representations of the human figure in a roughly-finished style. In 1961 he began to use medical bandages to cast plaster molds of figures from life, the first a self-portrait entitled *Man at a Table.* Initially, Segal was viewed as making emotionally-detached sculptures. His method of lifting direct molds from his subjects rather than hand-carving these representations further associated him with Warhol and Lichtenstein. While this innovation is indeed notable, from today's perspective, the Pompeii-like ghostly entombment of persons exudes an eerie, disquieting, ultimately romantic, sentimental effect. The rough encrusted surfaces seem to conjoin his interests with that of the existential anxiety explored by figures of Alberto Giacometti.

By 1970, Segal altered his technique, using the plaster cast as a mold into which he poured liquid plaster. This produced a more detailed rendering of the figure, which Segal often painted a bright color. Since the '80s his subject matter has expanded to include Cezannesque still lifes. He received an honorary doctorate from Rutgers University in 1970, and has most recently produced a number of large public sculptures as well as designed the cover for *Time* magazine in 1983.

WAYNE THIEBAUD
<div style="text-align:right">American, b.1920</div>

A painter of international acclaim, Wayne Thiebaud began his career as a cartoonist and graphic designer. After working briefly in the animation department of Walt Disney Studios and studying commercial art, he worked for ten years as a free-lance cartoonist and illustrator. He became a painter in 1949, studying at the San Jose State College and then California State College, graduating with an MA in 1953. Images of ordinary objects such as gum-ball dispensers and food counters appeared in his work as early as 1953, but were veiled beneath layers of Abstract Expressionist brushstrokes. Strongly influenced by the work of Edward Hopper, Thiebaud gradually adopted a more realist style, concentrating on consumer goods, like food, isolated on a monochromatic background. This link in subject matter to the consumer world characterizes Thiebaud's work as Pop Art. When his works were first shown in San Francisco, he was soon dubbed the Carbohydrate Morandi' because of his celebration of all-American junk food. In 1963 he began depicting figures, investigating their relationship to one another and to objects, but portraying them in a consumer fashion. Most recently, he has continued to paint the images of mass-produced consumer goods as well as cityscapes of San Francisco, landscapes and animals.

ANDY WARHOL
American, 1928-87

The "Pope of Pop," began his career as a successful commercial illustrator and window designer in New York after studying pictorial design, art history, sociology and psychology at the Carnegie Institute of Technology in Pittsburgh (1945-1949). During the '50s Warhol worked for *Vogue* and *Harper's Bazaar*, did window displays for Bonwit Teller and his first advertisements for I. Miller shoe company (the shoe motif would resurface in his earliest paintings of commercial goods). His early Pop paintings, including *Saturday's Popeye* and *Superman* (both 1961), were first used as backdrops for a window display at Bonwit Teller department Store in 1961. On learning that Lichtenstein had also adopted comic strip heroes as his subjects, Warhol turned to consumer products, producing his first multiple repetitive images of Campbell's soup cans and Coca-Cola bottles in 1962. With these new multiples he tried to mimic the machine-like process of assembly-line production used in creating the products he depicted. His introduction to screenprinting in 1962 led him to perfect this effect and he encouraged the impression that his multiples were churned out by his entourage of assistants from *the Factory*, as his studio was called. Warhol's images of the '60s epitomized both the glamour and the violence of American life, mass-producing publicity shots of Marilyn Monroe and Liz Taylor, at the same time as his disturbing images of the electric chair.

In the latter '60s Warhol spent the majority of his time making films (*Kiss* and *Sleep*), producing a record for the rock band the *Velvet Underground* and promoting them in live multimedia performances, making his first movie *Flash*, and publishing the first issue of *Interview* Magazine. In July, 1968, Warhol suffered a near fatal gunshot wound inflicted by former groupie Valerie Solanis, the sole member of S.C.U.M. (Society for Cutting Up Men). In 1980 he oversaw the production of a new TV cable station, *Andy Warhol's TV*, and returned to an earlier theme of money in *Dollar Signs*. Encouraged by a resurgence of the Pop spirit in a new generation of artists emerging on the New York scene, Warhol collaborated with graffiti artist Jean Michel Basquiat. He died following a routine gall-bladder operation in 1987.

Originally employed as a commercial artist in New York, Andy Warhol translated the hallmark techniques of the illustrator into a new and exciting form of art. He used as subject matter for his paintings of 1959-1960, comic strip superstar characters such as *Dick Tracy* or *Nancy*. His interest in publicly-known, recognizable objects of everyday life led him to paint the most commonly encountered images within contemporary consumer culture: dollar bills, commercial products such as Coca-Cola bottles, Brillo boxes and Campbell's soup tins. Sometimes they appeared as single frontal icons, other times they were presented in multiples in serried ranks just as we might expect to encounter them on supermarket shelves.

Warhol was an innovator in the application of the commercial silkscreen process to art making. Not only did it create visual results which echoed the consumer culture of the '60s, silkscreening also imposed a distance between artist and visual product, stripping art of any seeming distinctive authorship and creating works that appeared artless and devoid of skill and emotional commitment—mere deteriorating copies of a better original.

In the seventies and eighties, Warhol became the society portrait painter *par excellence*. He was sought after and commissioned to produce a number of celebrity portraits over the years: *Wayne Gretsky 99* (1984) and *Karen Kain* (1982) are a continuation of Warhol's interest in celebrity personalities commonly seen in magazines, on posters and on television. Though these prints are *mechanically* reproduced and show signs of *image deterioration* common to his mass-produced images, it is difficult to overlook the impact of the aesthetic qualities of the colors chosen. Buried beneath the outward pretext of a completely mechanized, unconsidered process exists the element of artistic choice. This is particularly evident in the multiple trial proofs explored within his Gretsky prints.

TOM WESSELMANN
American, b.1931

Now an internationally acclaimed artist, Tom Wesselmann originally studied psychology at the University of Cincinnati between the years of 1952 and 1956. During the latter half of his studies he also attended the Art Academy of Cincinnati, continuing at Cooper Union in New York, under Nicolas Marsicano until 1959. His early work was Abstract Expressionist in the style of de Kooning, but by 1959 he was experimenting with small, abstract collages of figures in interiors. These collages led to a series of nudes in 1960, and in 1961, to the *Little American Nude* series. Feeling the need to work at a much larger scale, Wessselmann used one of his smaller collages as a basis for *Great American Nude #1*: a collage-based painting restricted to the colors of red, blue and white. The title is an ironic reference to other "Great American" creations such as the novel or dream. His style, coloring, and the simplification and pose of the figure refers to works by Matisse. He continued this series into the early '70s, characterized increasingly by an overt, shockingly direct depiction of eroticism.

In 1962 Wesselmann produced *Still Life* Assemblages using modern objects and advertising imagery. He continued his

Interiors series using emphatically modern, synthetic materials. His *Bathtub Collage* series, begun in 1963, pushed the depiction of intimate objects to an extreme, vulgarly emphasizing an implicit voyeurism through the use of real objects. He stretched the barrier between painting and sculpture through his large-scale, free-standing canvas works. More recently Wesselmann has worked on a series of brightly painted drawings, greatly enlarging quick sketches and cutting them from sheets of aluminum and steel. His choice of color and interior assemblages provide interesting comparison with the work of Canadian, Greg Curnoe.

BRITISH POP

PETER BLAKE
British, b.1932

Originally trained as a graphic artist, Blake completed his first Pop Art works while attending the Royal College of Art in London. His fascination with folk art images sprang from teenage visits to local fairgrounds and wrestling matches, imagery that would recur throughout Blake's career. These images would also characterize Pop Art in Britain for the following decade. Many of Blake's works are painted to appear as if they were found pieces of fairground art and advertisements. Later pieces incorporate printmaking techniques and collage pictures and advertisements from the media. In 1967 Blake designed the cover to The Beatles' *Sergeant Pepper* album. He was elected R.A. in 1974, and third Associate Artist to the National Gallery in London in 1994.

A pioneer member of the English Pop Art movement which began in the late 1950s, Peter Blake's images are often viewed as more sentimental than those of other British and American Pop artists. Like many Pop artists, Blake draws from mass produced sources such as posters, labels and advertisements, yet often avoids the flashy and glitzy images of popular culture typically found in the work of artists such as Andy Warhol or Richard Hamilton. Blake was interested in the new waves of technology and mass-media which bombarded most every home in the early fifties. Blake was associated with the first of a group of Pop artists to emerge from the Royal College of Art in London such as Ronald Kitaj, Richard Smith, David Hockney and Joe Tilson. Alongside Eduardo Paolozzi, Blake was one of the first artists in this group to develop a collage technique whereby he would assemble a variety of vastly anachronistic and stylistically dissimilar elements, seeing past the surface differences and uniting them in a common thematic concern. Blake's images are often taken from his immediate environment and frequently contain autobiographical content. Many of his Pop Art works contain figures of carnival folk, wrestlers, pin-up girls, personal acquaintances and himself.

Blake's Side Show series is a series of five black and white prints based on posters of local carnival personalities. Revealed in this series is Blake's long-held fascination with the eccentric fairground characters widely known in England as "carnies." Blake's first Pop images in 1954 were of circus personalities, painted to resemble the poster advertisements from which they came. The Side Show series of 1974-78 was completed at a time when Pop Art as an established style was considered a waning movement. Even within the simple prints of this series Blake's characteristic infusion of humanity and subtle sentimentality into an otherwise sterile image is evident.

Costume Life Drawing is possibly an extension of Blake's series of "Pin-up" girls during the 1960s. In his portrayal of popular magazine sex-objects, he returns to the figures a sense of humanity, depicting them as real people with a sensitivity lost in the magazine advertisements. Blake often created work based on individuals in his own life as well. *Girl in a Poppy Field* (1974) was printed while Blake lived in the countryside with his family. It is quite possibly a portrait of one of his daughters. Blake pays particular attention to surface, treating it in such a way that it becomes very much a physical object. Many of Blake's prints take on an almost painterly appearance, as if created by a brush loaded with pigment. Appearing more like paintings than mass-produced advertisements, his prints lack the smooth, clean lines and pure fields of color found in those of artists such as Patrick Caufield and Andy Warhol, yet they still explore popular images of everyday life: his everyday life.

PATRICK CAULFIELD
British, b. 1936

Although he did not consider himself a Pop artist and avoided using imagery from popular culture, Caulfield's work exhibits the spirit of the Pop Art movement through his use of a flat, geometric, impersonal style to portray the objects and settings of everyday life. Caulfield studied at the Royal College of Art just a few years after Peter Blake and remained in close association with other Pop artists in Britain and the United States. He has produced a number of paintings; however his paintings have

been infrequently displayed in North America. Most audiences know him better through his screenprints. This media lends itself well to his use of simple lines and areas of flat color. Despite their starkly-reduced formal elements and prosaic subject matter, Caulfield's prints convey a strong sense of mood and atmosphere, combining levels of illustrative expression with a naive pictorial language, in which personal, social, political and artistic images meet.

His images reflect the mundane objects which surround us: bottles, lamps, ceramic bowls and the domestic environments in which they are found. Common subjects in his prints include interior scenes: cliché tourist scenes of boats, ruins and churches; or subjects piquing his interest, such as his fascination with cloisonne. In most of Caulfield's prints, graphically emphatic line dominates, second in importance only to color.

He painted mostly on hardboard until 1965 when he began to produce screenprints, a medium well suited to the flat areas of color, bold lines and patterns distinctive of his work. His choice of subject matter alludes to the centuries-old tradition of still life painting. In this respect he also joins generations of British artists such as Ben Nicholson and William Scott in their preference for exceedingly modest objects treated as artistic central characters. Like these artists, Caulfield too chooses an informal composition and understated surface treatment. It is only his garish color that breaks with British politeness and restraint. It is this rude, almost vulgar, color which pushes Caulfield's work in a direction distinctly different from the formally elegant, classic beauty pursued by Lichtenstein.

TONY CRAGG
British, b. 1949

Tony Cragg is the first member of a new generation of British sculptors to appear in the 1980s. Like so many post-war British artists, Cragg centers his work around the values of the mundane object. In *Shoe*, he assembles discarded products of consumption of the daily world retrieved from his surroundings. Like that of Rauschenberg, Cragg's earliest work of the late seventies and early eighties was comprised of accumulations of found objects grouped together or assembled in symbolic shapes such as a figure, a flag. The objects were usually chosen according to one unifying factor, such as form or color. In the 1980s Cragg incorporated organic objects, such as wood. Many of his works used the human body and its systems as models for conceiving sculpture, exploring the relationship between the object world and the body. His most recent works break down the barriers between the organic and inorganic, using consumer objects to create organic forms. Cragg's interest in the products of industry and culture stem from his earlier career as a technician in a rubber research laboratory. During this time he became interested in art, and in his first drawings he began to consider the objects around him. He attended Gloucester College of Art and Design and the Wimbleton School of Art before receiving an MA from the Royal College of Art in London in 1977. In the same year, Cragg moved to Wuppertal, Germany, where he has lived and worked ever since.

MICHAEL CRAIG-MARTIN
British, b.1941

Born in Dublin in 1941, Michael Craig-Martin was educated in the United States at the Yale School of Art, where he acquired the spirit of high Modernism from his teacher Joseph Albers. In 1966 Craig-Martin returned to Britain to teach at the Bath Academy of Art at Corsham, teaching at Goldsmiths College until 1988 where he greatly influenced a new generation of British artists including Damian Hirst, Fiona Rae, Ian Davenport and Julian Opie. His diverse work in painting, drawing, and sculpture is informed by the same nature of radical inquiry that characterizes the art of the 1960s and 1970s. Craig-Martin's work challenges both how we interpret objects and what materials are appropriate for making art. One of his most well-known works is comprised of a glass of water set high on a shelf, accompanied by text claiming to have changed the physical substance of the glass into an oak tree. In 1975 he began a series of wall drawings which became one of his most important bodies of work. With the simplicity of minimalism, Pop imagery such as chairs, tables, ladders and bulbs were rendered on the wall. Mirroring the idea of wall renderings, he produced a series of wire objects set against the wall, their shadows casting lines and causing the work the hover between that of two and three-dimensions. His most recent work involves the use of black tape to "draw" household furniture onto dayglo walls, producing a radical "new sensuality" which further challenges the established notions of art.

RICHARD HAMILTON
British, b.1922

A leading figure of the British Pop Art movement, Richard Hamilton founded London's Independent Group in 1952, consisting of a group of artists, writers and architects who analyzed the products of mass culture. In 1956 he designed the poster for the Whitechapel Gallery exhibition "This is Tomorrow." The poster design, comprised of collage entitled *Just what*

is it that makes today's homes so different, so appealing?, is recognized as one of the earliest Pop works. His following work consisted of paintings using a large range of images gleaned from advertising. He later switched to screenprinting which allowed him to incorporate fragmented images from a number of sources, including photography. Hamilton's interest in the imagery of the popular media has been linked to his early career in advertising. He studied at the Academy and the Slade School of Art in London, and has taught at the University of Newcastle-upon-Thyme. Today Hamilton experiments with computer prints and paintings that revitalize the age-old theme, mortality, through the device of *memento mori.*

DAVID HOCKNEY
<div style="text-align: right">British, b.1937</div>

David Hockney's close association with many of the leading figures in British and American Pop Art, as well as his early penchant for subjects such as consumer goods and references to graffiti and packaging, link his work to that of Pop Art. He attended the Bradford College of Art until 1957, and then studied alongside R.B. Kitaj, Allen Jones, Peter Phillips and Patrick Caulfield at the Royal College of Art in London until 1962. Hockney came to attention through his influential suite of prints *A Rake's Progress.*

Although he is still fondly included within discussions of British Pop, Hockney has spent the majority of his life in America, moving first to Iowa to teach in 1964, then to Colorado in 1965. For decades his work has been synonymous with Southern California's open spaces, rectilinear architecture, vivid light and bright color. He also began to use the camera and other photographically-based images in his work. Hockney's more recent pursuits have included writing (*China Diary*, 1981), cover designs for *Vogue*, carpet designs, and sets and costumes for a number of opera productions including Igor Stravinsky's "The Rake's Progress" (1975).

ALLEN JONES
<div style="text-align: right">British, b.1937</div>

Though expelled from the Royal College of Art after his first year, Allen Jones' friendships and involvement with key artists of the British Pop Art movement—R.B. Kitaj, Peter Phillips, David Hockney, and Derek Boshier—led him to pursue this direction for the rest of his career. In 1961 Jones' first reference to comic strips appeared in his work, followed by a series of *Bus* paintings which investigated the relationship between the shape of the canvas and implied movement. He moved to New York in 1964, where David Hockney drew his attention to mass-produced consumer goods imagery. His style took on a less painterly, more geometric style, and moved from a slight eroticism to openly fetishistic images. Jones' most extreme Pop Art statements took the form of a set of life-size fiberglass sculptures of women in high leather boots and bondage wear, posturing as pieces of furniture. He has toured across the United States and Canada, serving as visiting professor and lecturer, for instance at the University of South Florida, Tampa. His recent work has returned to a more formal and stylized approach to the figure, although color and the human form remain his fundamental concern.

Allen Jones' principal subject matter from the early sixties has centered around the human figure. *Strongman*, a 1988 abstracted sculpture joins with British artist Peter Blake's *Side Show* to explore fascination with role-playing oddities at the fringe-edge of society: the circus and the carnival. In their case, the *strongman* is clearly a *straw man*, a type of wishful thinking, projecting an image of a confident, strident, self-composed robust male. How completely this image will tumble as they meet their match under the withering gaze of the woman seductress, the principal player in Jones' work. Jones critiques the human condition through the deployment of the rich symbolism and disquieting otherworldly conventions of the carnival and other adult *attractions.*

Jones' main subject, the human form, has more specifically been fixated upon the female figure in various states of undress. The nude has been a classic, time-honored subject matter for artists. Pop artists generally have eschewed the *art-school, atelier, studio nude* and the standard stock of artificial poses in favor of presenting the human figure in more *naturally-occurring contemporary situations and contortions.* Works by George Segal, Peter Blake, Tom Wesselmann, and Joyce Wieland in the exhibition enter this battle field to examine the cultural portrayal of women. In a comparative sense, Jim Dine also turns away from the usual route of the male artist drawing directly from a live female model. Instead, he opts to use a mediated source and ironic reference by portraying the female figure as drawn from cheap tourist shop copy of the *Venus de Milo.* His work thereby enters the social debate and critique of questions of beauty, personifications of perfection, ideal human form, sexuality and the objectification of the *fairer* sex. Allen Jones' *Copied from a Higher-Priced Original* is a perfect foil for these issues and meets the construction of this artificial cultural stereotype of beauty head on! Works by Canadian artists also enter this fray, Michael Snow's Walking Woman series, Dennis Burton's early sixties paintings, Robert Markle, John Meredith

and a host of others all grapple with the *constructed* female beauty portrayed in everyday contemporary settings and garb.

The most characteristic images of Jones have unquestionably been drawn from the Burlesque, the bar trollop, and his fascination with the carnival. Therein, the cover of darkness and contemporary social conventions and institutionalized voyeurism, cloak evident lust and provide solace for those with conflicting moral pangs. The male gaze is presented front and center. The female in Jones' work is pictured as an over-powering figure, larger than life (larger than male?). She is a role-playing, manipulative performer, an insidious dominatrix, an alluring siren, *femme fatale* toying with male weakness and yearning. Jones' women are mesmerizing voluptuous objects of over-wrought sexual desire, mysterious, powerful yet ultimately menacing. Never mind the fact that Jones' women are self-evidently cartoons, physically exaggerated beyond believability, trivialized to their utmost, these improbable, allusive beauties still hit their mark. These too are the messages of the major painting *Pin-up Girl* (1962), by fellow British Pop artist, Peter Blake and countless variations upon *The Great American Nude* by Tom Wesselmann. They enter the dialogue and legacy of other moralistic reflections concerning attraction-repulsion to our base animal instincts that we encounter throughout 20th century art. Notably, we think of Reginald Marsh's epic Coney Island painting *Virginia Reel* (1937), Phillip Evergood's unsettling grotesquerie of the Three Graces (*Bathers at Dusk*, 1955), and Jones' Royal College of Art classmate, David Hockney's tale of debauchery, *A Rake's Progress* (1961-63).

The darker side of sexual lust resonates within the outstanding examples of Jones' works: *Bar I & II, Chalice IV, Clasp*. Their subject matter and treatment are classic Jones material; precisely those elements for which he has been an internationally recognized, published artist, widely exhibited in superlative commercial galleries and collected by the worlds' major art museums. Even within the dignified cultural setting of Jones' *Brahms Clarinet Quintet*, the ballroom demeanor and embrace seems to give over to more direct contact. Couples melt into passionate clasp. Here is Jones at his seductive best; his masterful, painterly touch and extraordinary flair bathe the figures in a swirl of emotionally-charged gestures laden with captivating coloration and immoderate dollops of hot pink.

The University of Lethbridge Art Gallery nearly two decades ago purchased its first works by Jones, screen prints from The Magician's Suite. These were joined by one of Jones' most singularly important paintings, *Copied From a Higher-Priced Original*. Recently Jones' representation was updated through the addition of works characteristic of his concerns of the eighties, his only sculptural work as well as first lithographs and watercolors. Jones' dark visions of human sexual folly, oblivion and reckless abandon find unexpected parallel in recent work by Canadian women artists particularly: Sandra Meigs, Joice Hall, Marie Lanoo, Joanne Tod, Susan Scott. Jones' style, his sense of heightened emotional drama through graphic exaggeration and lurid coloration continues to be admired by a variety of artists, this particularly so of those artists associated with the Funk traditions of Chicago.

R.B. KITAJ
American, b.1932

By the time R. B. Kitaj arrived in London in his mid-twenties, he had traveled extensively as a seaman and acquired first hand knowledge of modern European and contemporary American art, such as Abstract Expressionism and the work of Robert Rauschenberg. He studied at the Cooper Union in New York, the Akademie der Bildenden Kunste in Vienna and the Ruskin School of Art in Oxford before attending the Royal College of Art in London (1959-61), where he had a strong influence on his fellow students, including his friend David Hockney. Kitaj showed at the 1962 *Young Contemporaries* exhibitions in the RCA Galleries and taught at several schools including the Slade School of Art in London. He collaborated with Eduardo Paolozzi in 1962, incorporating collage into his work for the first time. He remains closest to Pop in his use of photographs or frame enlargements from films. From 1963 to 1975 he was a prolific maker of screenprints. During a visit to the United States, Kitaj became friends with Jim Dine, and after his return to England met Richard Hamilton. He has been included in major exhibitions such as the Venice Biennale (1964), Documenta III and Documenta IV. In his work he shows the political and social effects of contemporary mass culture, often referring to historical events and their manipulation and consumption via the mass media.

JOHN LATHAM
British, b. 1921 in Africa

John Latham was born in Africa, but raised in London. He is known as a prominent figure in British art. From 1934 to 1939, he attended Winchester College and then began studying at various art colleges around London. His works have been attributed to several different art movements, such as Informel, Conceptual and Minimal art, and Happenings. He frequently

takes a scientific approach, applying theories of physics, time, and relativity. In 1954, he created his first "process sculpture" by spraying a gun filled with black paint on a white surface. He referred to this as "Idiom of 1954." This same year he co-founded the "Institute for the Study of Mental Images" with friends Anita Kohsen and Clive Gregory. The point of this Institute was to investigate and develop a "psycho-physical cosmology." In 1958, Latham created his first book relief, *Burial of Count Orgaz*, derived from El Greco's painting, and intended to represent the association between heaven and earth. In order to make a statement about the written word, Latham created his first burning-of-books sculptures, *Skoob Tower Ceremonies*, in 1964; the sculpture included constructing, shaping, and burning tall stacks of books. In 1965, he and several friends co-founded the Artist Placement Group, which co-existed with his Time-Base theory. The function of this group was to place artists in various institutions where the artists could learn and participate in decision-making processes. Latham has moved from spray paint and books to glass, recently, in works like *God is Great*, which examines the ideology of religion and the spirit. *Biographical sketch prepared by Becky Jones.*]

BRUCE McLEAN
Scottish, b. 1944

Bruce McLean, a key British art figure, is best known for his versatility with art media from painting and sculpture to printmaking and performance pieces. He was born in Glasgow and attended classes at Glasgow School of Art. In 1963, he moved to London and began to study sculpture at St. Martin's School of Art where he familiarized himself with Anthony Caro's 1950 creation of New Sculpture. It was his disapproval of this that motivated him to take his art beyond the classroom walls to the streets, where he constructed art out of disposable objects. McLean's sculptures of himself led to his performance pieces and paintings. In his art work, the body became a mode of expression and movement. McLean's paintings demonstrate his preoccupation with both gestural and expressionistic figures; he paints as though his works are performance pieces. While teaching at Maidstone College of Art in 1971, he created the well-known performance piece *High up on a Baroque Palazzo*. In 1979, he parodied both the glorification and mediocrity of an architect in a performance entitled *The Masterwork: Award Winning Fishknife*. McLean won a DAAD scholarship to Berlin in 1981. In addition to his performances and gestural paintings, he has recently begun creating ceramic, plates, glasses, and vases, which display gestural and expressive figures. *Biographical sketch prepared by Becky Jones.*]

EDUARDO PAOLOZZI
British, b.1924

A significant member of London's Independent Group, Paolozzi greatly influenced the development of Pop Art. Having kept a scrapbook of images since 1947, he reproduced the pages for viewing during a landmark lecture to the Independent Group in 1952. He presented slides made from scrapbook images, fragments from comic books, postcards, magazines and advertisements. The presentation of these collage images sparked a controversial debate among the Group's members; these images are now considered amongst the earliest forerunners of Pop Art. Born in Scotland to Italian parents, Paolozzi attended evening classes at the Edinburgh College of Art and studied at St. Martin's School of Art, later transferring to London's Slade School of Art, where he graduated in 1947. He moved to Paris for three years where he met artists such as Giacometti, Arp, Brancusi, Braque and Leger, and became involved in Dadaism and Surrealism. In 1950, Paolozzi returned to London, quickly becoming a leading member of the Independent Group with other artists such as Richard Hamilton. His bronze sculptures of the 1950s contained elements that presaged his later Pop works, including references to robots and the incorporation of found objects into the maquette before casting. He emerged fully onto the Pop Art scene in 1962 with his abstract, robot-like figures such as *Four Towers* and *Solo*. By the mid-1960s these sculptures began to take on more geometric proportions with glossy industrial finishes and bright primary colors. At the same time Paolozzi also began to produce collage-based screenprints which are among his most important contributions to Pop Art. Though his later work continued to make reference to the mass media and contain elements of collage, he began to explore abstract formal language and returned to the use of aluminum, stainless steel and chromed steel. He has taught all over the world as guest professor and lecturer including Europe, the United States and Canada.

Of all his work, Paolozzi's screenprints are said to have had the largest impact on Pop Art. His innovative use of the collage technique soon translated onto screenprint, which retained a collage-like effect, but played down the individuality of each article used, instilling within the work a stronger sense of unity. In his use of disparate images from newspapers and magazines he attempted to capture the "schizophrenic quality of life," where the individual is confronted everyday with a barrage of imagery from mass-media communication. Though the offset lithograph entitled *Me* was completed in the early

'70s, it is indicative of much of his work in the '60s. His use of popular imagery from the mass media characterizes many of his prints as Pop Art. In *Me*, he juxtaposes the diverse images that have found their way into the average American home: a toy astronaut suit, strawberries, a figure from a magazine. Characteristic of many of his works, Paolozzi leaves his viewers with a number of images from which they must draw their own interpretations.

PETER PHILLIPS
British, b.1939

At the young age of thirteen, Peter Phillips began his art education at the Moseley Road Secondary School of Art in Birmingham. There his diverse training in the areas of painting and decorating, sign-writing, heraldry, silversmithing, graphic design and technical draughtsmanship permanently left its mark and influenced his style. Between 1959 and 1962 he attended the Royal College of Art with other rising Pop artists Hockney, Kitaj, Jones, Boshier and Caulfield. Friction between himself and his tutors in painting school led to his transfer to the Television School in 1961, but the following year he still graduated with a painting degree. He was greatly influenced by the works of Americans Jasper Johns and Robert Rauschenberg. He was particularly interested in American culture and reflected its commercial iconography and aggressive advertising style. Board games, funfairs, pin-ups, and comic books were common sources for imagery, painted in a bold, flat style. In 1964 Phillips lived in New York for two years on a scholarship, traveling around North America by car with Allen Jones in 1965. While in New York, his incorporation of the air brush into his painting technique produced a flat surface that appeared glossy and machine made. In the '80s Phillips' style took on a more contemplative mood and abstract appearance, yet remained based on the fragments from images of magazines and photographs. Phillips has taught and traveled throughout Europe, Australia, Far East Asia and North America.

JOE TILSON
British, b.1928

Before attending art school, Joe Tilson worked as a carpenter and cabinet maker for two years. After serving in the RAF from 1946 to 1949, he attended the St. Martin's School of Art, graduating from the Royal College of Art in 1955. As a student he abandoned the figure to explore the Abstract Expressionist painting style after viewing an exhibition at the Tate Gallery. In 1961 Tilson's previous woodworking experience played a large role in his artmaking as he began producing constructed objects that would link him to the new generation of Pop artists emerging from the Royal College at that time. Incorporating elements that soon became integral to his work—bright colors, bold, simplified structures and stenciled lettering—these wooden constructions of the early 1960s were among his most personal contributions to Pop. He and his wife also played an important role in bringing artists together at informal gatherings at their home. By the mid '60s Tilson began to use silkscreening to produce quintessentially Pop works, such as *P.C. from NYC* (1965). Shortly after his move to Wiltshire from London, his disenchantment with the mechanical methods of production led him to take up etching and produce wooden constructions once again. His deepest interests included political and ecological concerns, alchemy, our relationships to nature and subjects drawn from pre-Classical mythology. Tilson has taught in a number of schools in England and has traveled internationally as a guest artist and lecturer.

The early works of Joe Tilson, such as *Two Wristwatches* 1965, (University of Lethbridge) are readily describable within the characteristics commonly outlined for Pop, and would bear immediate comparison in subject selection and method of execution to Dine's *Pitchfork*. However, increasingly, Tilson's work has moved steadily towards abstract language, retaining only vestiges of his Pop-related beginnings. The structure of his works perhaps is the longest lingering association: emphasis upon constructions, compartmentalized boxes of *data*, addition of found objects as principal subject matter. Like Dine, Tilson has also created culturally recognizable icons, signature-style elements that are immediately identifiable as the sole language of this specific artist.

Tilson's work has continually explored ideas of abstract language, icons and their meanings, and compartmentalized data. He explores the late sixties fascination with the earth and spirituality. He is seeking to break down the meaning of words into a more meaningful set of icons—icons which are closer to the cryptic, long-forgotten languages of the ancients, a language that can unlock their secrets and reconnect us with the mysteries of the earth and of life.

Increasingly Tilson's concerns embrace nature, ecology. His work appears to posit itself in contradiction to the notion of progress through technology, and strives to evoke the mysteries and wisdom of the ancients, the classical search for ideals, knowledge. His work creates a primer, a physical vocabulary that attempts—like early natural history museums—to know the world through conscious acts of collecting, intense scrutiny, discrimination and sensitive observation. Tilson's boxes sort,

analyze, categorize, and chronicle the enigmatic, iconic objects he has collected. The work bespeaks a quest for relationship with cosmic order, to reconnect with lost knowledge and wisdom of the ancients by reference to cryptic long-forgotten languages, scripts and hieroglyphic-style writing.

Martin Luther King by Tilson, is one of the most poignant works created in the Pop idiom. Five separate image compartments comprise the work: a portrait of Dr. King, the news flash photo of the slain leader, a palm print with an x-marking the spot, an image of Rietveld's modernist chair and an architectural rendering reminiscent of the Bauhaus. It is a melancholic, introspective work, articulated by restraint, subdued natural organic color. Tilson's poetry is inconclusive, fragmentary. Yet, a certain reading prevails. Tilson's *MLK* is a sad lament, a recognition of the damaged human animal. On the one hand, modernist ideals proclaim a world that will be saved through the uplifting, morally-elevating effects of contact with *good design*. Dr. King's body lies on the balcony of the Lorraine Motel (itself a vernacular debased copy of the modern building) cut down by the hand of an assassin. Intense sorrow, not anger, and recognition of our collective failings, rather than recrimination or despair, are the message of Tilson's memorial.

CANADIAN POP

IAIN BAXTER
Canadian, b. 1936

Born in Middleborough, England, Baxter grew up in Alberta and British Columbia, Canada. He studied Zoology at the University of Idaho, where he was offered an opportunity to illustrate a wildlife guide of the northern Rocky Mountains. He received an MFA at Washington State University, studying with Gaylen Hansen, a marvelous, wacky iconoclast who greatly encouraged Baxter's latent impishness. In 1961, Baxter traveled to Japan to study painting. It was during his travels that he discovered his interest in the relationship between organisms and their environments. Baxter is best known for his landscape paintings and videos, which he refers to as "considered landscapes" and "infoscapes." He believes that landscapes offer information about people, ideas, and experiences, a conceptual context. Before becoming involved in Conceptual landscapes, Baxter had explored Abstract Expressionism as well as other modes of painting and even illustration work. In 1966, he created a public relations firm, N.E. Thing Company, with his first wife, Ingrid. The Company gave Baxter a means by which to create and exhibit many of his landscapes, such as *1/4 Mile Landscape* and *Suite of Canadian Landscapes*. In 1992, Baxter decided to move from paper to video, filming the technology and landscapes of Canada in projects such as *One Canada Video* and *Landscape*. He continues to work on video installations and teach at the University of Windsor, Visual Arts Department. [*Biographical sketch prepared by Becky Jones.*]

DAVID BUCHAN
Canadian, 1950-1994

David Buchan was known as a performance artist, though his work also included photography, video, and commercial media and advertisement manipulation. A native of Grimsby, Ontario, Buchan studied fine art at York University in the early '70s. Starting out as a painter, his work contained a strong Pop slant, incorporating song lyrics and related imagery. After his graduation he moved to Montreal and ceased painting, focusing instead upon charting relations and interconnections with friends and acquaintances. This signaled the new direction of his art: he began to draw on the facts and images of the contemporary world. Akin to the art of Toronto's General Idea, Buchan immersed himself in examining how mass media and advertising in particular structures the way we view ourselves. An entire sub-culture revolved around Buchan, General Idea and their entourage. They threw themselves headlong into the reckless abandon of cabaret night-life, spoofing and mocking middle-class values, notions of sexuality and gender, and unveiling cultural power relationships. The serious, high-minded aloofness of institutionalized art structures did not escape their penetrating gaze.

Buchan's *Modern Fashions: or an introduction to the language of partial seduction*, is one of the wittiest and most insightful send-ups of the ad industry. Rather than devolving into pure camp, Buchan plots a love/hate relationship with the purveyors of glamour and creators of taste. Buchan was a natural performer, who reveled in the opportunity to role play and construct images of himself as if he were a cultural icon. These photos predate the highly regarded *Film Stills* series of Cindy Sherman with which they could be intriguingly paired. Buchan's own ad copy messages are delivered with consummate skill, the artist taking considerable pleasure in double entendre and gamesmanship.

DENNIS BURTON
Canadian, b.1933

Born in Lethbridge, Alberta, Dennis Burton's artistic career has spanned five decades and his work has included the diverse styles of painterly and hard-edged abstraction as well as paintings and drawings of superb draughtsmanship. His early interest in abstraction stemmed from the influence of American Abstract Expressionism and the Toronto Group Painters Eleven in the '50s and early '60s. During his time at Ontario College of Art in the mid-'50s, Burton became a key figure in the Toronto "happenings" and won numerous awards for his work, including a travel scholarship to study at the University of Southern California. After a brief stint as a graphic artist, he returned to painting full-time in 1960. His work has passed through a number of stylistic phases, the two most recognized being his abstract works, and those depicting women clad only in their underwear. In the mid-sixties Burton's fusion of his interest in abstraction and the female figure began with a series later dubbed "Garterbeltmania," erotic drawings and paintings done in a Pop Art idiom, painted at the same time Allen Jones produced his erotic Pop series "The Magician's Suite." Like Jones, Burton rejects the relevance of perpetuating cliched, contrived poses of the studio nude. Audiences found his partly-clothed models even more sexually-charged than traditional nude studies. In his most recent work, Burton alternates between painterly abstraction and figuration. Known internationally, he has taught and exhibited in both Canada and the United States. He lives in Vancouver, British Columbia.

CHRIS CRAN
Canadian, b.1949

Born in Ocean Falls, British Columbia, Chris Cran now lives and works in Calgary. His engaging and often humorous paintings are well known throughout Canada, and have appeared in several venues in the United States. Cran studied at the Kootenay School of Art in Nelson, British Columbia, before attending the Alberta College of Art in Calgary, Alberta in the late seventies. He is best known for his "self-portraits," dating 1984 to 1989, and his more recent series of "half-tone stripe paintings" taken up since 1989. In both series, Cran's paintings explore the rhetoric of visual images, revealing how meaning is constructed from the interplay between the optical, cognitive and culturally determined. In his "self-portraits" Cran used a realist style to depict narrative scenes involving himself, often accompanied by seemingly out-of-place iconographic images or placed within absurd situations. In his following series referred to as "half-tone stripe paintings," Cran appropriates half-tone reproductions in pulp magazines of the 1950s and 1960s. By reproducing the already degenerated image at monumental proportions, the half-tone dots are revealed. The picture is further broken up by blank lines produced by the stripping of intermittent lines of tape. Up close, the image is lost to abstraction; far away, the images gel into a recognizable form. In this way they address, among other issues, the disintegration and formulation of visual meaning.

GREG CURNOE
Canadian, 1936 -1992

Born in London, Ontario, Curnoe attended the Doon School of Art near Kitchener, Ontario, and in 1960 graduated from the Ontario College of Art in Toronto. Following the influence of Dada, he, along with other artists, rejected much of established culture and founded the Nihilist Party in 1962. In London, Ontario, that same year Curnoe staged the first Canadian "happening" and was a member of the Nihilist Spasm Band, a kazoo-free music group. He is best known for his paintings in which he incorporates captions into his images. His work is often aggressive in its patriotism, many of his writings and works revealing an anti-American sentiment. Curnoe's use of large-scale canvases, intense colors and text throughout, elevate the most mundane events in life to monumental proportions.

GATHIE FALK
Canadian, b.1928

Gathie Falk is known for her exploration of the ordinary object in performance, sculpture, installation, ceramics, video and painting. She discovered art while upgrading her teaching degree at the University of British Columbia. Her first exhibition took place in 1965, and since then, her work has been viewed across Canada, the United States, and in Europe. She is known as one of the pioneers in Canadian performance art. Throughout her career she has honored the mundane things in life, changing them into the extraordinary and the revered. In 1978 she carried her subject matter into painting. Her most recent work consists of a combination of her strengths, using the canvas as the arena wherein she can address the relationships between ordinary objects and their power as symbols within different environments.

ATTILA RICHARD LUKACS
Canadian, b.1962

An expatriate Canadian living in Berlin since 1986, Attila Richard Lucaks was born in Edmonton. His family escaped the Hungarian Revolution of 1956 and brought their children up in Calgary, Alberta. In 1983 he attended the Emily Carr College of Art and Design in Vancouver and held his first solo show the same year. The following year Lukacs, together with three fellow students, held their first group show under the name "Futura Bold" which led to the 1985 Vancouver Art Gallery exhibition "Young Romantics," bringing Lucaks' work into the national and international spotlight. His work depicts the male body "in all its hysteria," often juxtaposing violent homosexual mythology with militaristic, neo-Nazi images, rooted in the current political, post-wall environment of present-day Berlin. His work has toured extensively throughout Canada, the United States and Europe.

MICHAEL SNOW
Canadian, b.1929

Internationally renowned visual artist, filmmaker, and musician, Michael Snow has worked in many media, including drawing, painting, sculpture and photography. After receiving a prize for art in high school, Snow specialized in design at the Ontario College of Art, while continuing to play music and develop his painting skills, independently. After a brief stint as a commercial artist, he spent 18 months traveling in Europe, visiting museums and galleries and drawing daily. On his return to Toronto, Snow received his introduction to film by working as an animator. His first solo show launched his career in 1956. He lived in the Soho neighborhood of New York City between 1962 and 1972, during which time his Walking Women series was created and his underground film *Wavelength* became recognized as a work altering the history of film. He has lived in Toronto for the last 30 years, his prolific and multi-dimensional work continues to be provoking and controversial.

TONY URQUHART
Canadian, b.1934

Tony Urquhart rose to critical prominence as an Abstract Expressionist painter in the late 1950s and early 1960s. He is linked to some of the major developments in contemporary Canadian art: the Toronto-based group of second-generation Abstract Expressionists and the London, Ontario, group including Greg Curnoe. Urquhart developed his own eccentric, personal and distinctive conception of form, laden with symbolic messages, setting his work apart from the rest. Following his encounters with the great cathedrals and prehistoric sites of Europe, his work in the 1970s changed dramatically, resulting in his trademark "box sculptures"—strange hybrids of architecture, reliquary and landscape. Through these boxes, as well as paintings, drawings and bronzes, Urquhart developed his own form of Surrealism. Stemming back to his childhood, when he would play among the caskets of his family's funeral home and the extensive gardens of his mortician grandmother, many of Urquhart's themes concern the processes of growth and death. Born in Niagara Falls, Ontario, he studied at the Albright Art School, a division of the University of Buffalo in Buffalo, New York, where he would have encountered De Kooning's *Gotham City News*. Founder of the Canadian Artists Representation (CAR), Urquhart has taught in a number of Canadian Universities and his work has been exhibited worldwide.

JOYCE WIELAND
Canadian, 1931-1998

Joyce Wieland was born in Toronto, the elder daughter of British immigrants. She studied commercial art at the Central Technical School. A filmmaker, painter, and assemblage artist, she was preoccupied with plane crashes and boat sinkings in early Pop Art work. Wieland and artist husband Michael Snow lived in New York between 1962 and 1972 before they returned to Toronto. She believed in democratizing art by blurring the line between crafts and high art, and "serving her country as an artist." Her work *Young Woman's Blues* was reproduced and discussed in Lucy Lippard's early survey book, *Pop Art*.

JOHN WILL
Canadian, b.1939

Born in Waterloo, Iowa, John Will received his BA and MFA in the United States before moving to Calgary, Alberta, in 1971. The finest technical lithographer in Canada, his early suite of etchings, *The Door*, bear comparison to that of another artist in Iowa at the time: David Hockney. Will's prints and paintings are known for their playfulness and self-directed satire which mask his frank observations and comparisons of Canada and the United States. His paintings often draw on the collage and commercial tendencies of Pop works, as well as the loose abstraction of the seventies, while molding these elements into a

style all his own. Artist, teacher and founder of Stride Gallery in Calgary, Will's work has been exhibited across Canada and the United States.

RUSSELL YURISTY
Canadian, b.1936

Born in Goodeve, Saskatchewan, Russell Yuristy received a Bachelor of Arts from the University of Saskatchewan before moving to the States and earning a Masters of Science in Art from the University of Wisconsin in 1967. In 1968 he returned to Canada where he attended the Emma Lake Workshop in Saskatchewan with Donald Judd. An artist employing various media including acrylic, oil, pen and ink, drawing, sculpture and ceramics, his narrative subject matter is selected from the things around him—baseball, people, animals, and daily objects. Having sprung from the Saskatchewan prairies, many of his ceramic pieces carry the same sensibilities shared by artists like David Thauberger and David Gilhooly. Yuristy has exhibited throughout Canada, and the States, as well as Europe, and Asia.

AMERICAN POP

Although the works touring from the University of Lethbridge Art Collection did not include selections by James Rosenquist, his monoprint lithograph The Kabuki Blushes, *1986, has been generously loaned to* The ABCs of Pop Art *by Graphicstudio of the University of South Florida. In Florida his* Tallahassee Murals *are installed in the Capitol building and are part of the Collection of the State of Florida.*

JAMES ROSENQUIST
American b. 1933

James Albert Rosenquist was born in Grand Forks, North Dakota, the only child of a mother of Norwegian descent and a father of Swedish descent. His family moved several times when he was quite young, settling in Minneapolis where he won a scholarship at age fourteen to the Minneapolis Art Institute. He later studied at the University of Minnesota, but it was a 1955 scholarship to the Art Students League that brought him first to New York to study with Will Barnet, George Grosz, Morris Kantor and others. He held part-time jobs including, in 1957, the job of billboard painter for A.H. Villepigue, Inc. and later for General Outdoor Advertising. Eventually he worked full-time at this trade for Artkraft Straus painting their billboards in Times Square and Brooklyn. In 1959, with fellow students Claes Oldenburg and Henry Pearson, Rosenquist attended drawing classes organized by Jack Youngerman and Robert Indiana. The same year he became the head painter at Artkraft Straus, but quit in 1960 to begin painting the backdrops of window displays for Bloomingdale's, Bonwit Teller, and Tiffany & Company. His first one-man show at Green Gallery in 1962 sold out, and in the same year, his work was included in "The New Realists" exhibition at Sidney Janis Gallery. In 1963 he received a mural commission for the New York World's Fair. His gallery career burgeoned thereafter with his first major international tour of *F-111* in the Fall of 1965. In 1980 his work was included in "Pop Art: Evolution of a Generation" at the Palazzo Grassi in Venice. In 1976 he completed murals for the Capitol in Tallahassee, Florida, and purchased property for his Florida studio in Aripeka. His 1980 work *Star Thief* was selected by the Dade County Art in Public Places Commission for the Miami International Airport, but due to controversy, installation was prevented. The work was exhibited in 1983 at the Center for the Fine Arts in Miami. Since 1973, Rosenquist has had a long and productive association with Graphicstudio of the University of South Florida.

Works loaned from the Collections of The University of Lethbridge Art Collections, Lethbridge, Alberta, Canada, with additional works on loan from the Appleton Museum of Art, Graphicstudio of the University of South Florida, and the Florida State University Museum of Fine Arts, respectively.

Arman (French-American, b. 1928), **Homage to Duchamp—To and For Rose Selavy**, 1973, mixed media sculpture, ed. 69/90, 18 x 9 x 3.75 inches (box). The University of Lethbridge Art Collections; gift of Myrna and John Daniels, 1992. Accession Number: 1992.116

Arman (French-American, b. 1928), **Untitled (paint brushes)**, 1991, mixed media sculpture, from a suite of 6 ed. 20, 26 x 12 x 2.25 inches. The University of Lethbridge Art Collections; gift of Myrna and John Daniels, 1992. Accession number: 1992.115 (tba)

Iain Baxter (Canadian, b. 1936), **Landscape**, 1990, acrylic on canvas, found objects , installed: 124.5 x 210 x 150 inches. The University of Lethbridge Art Collections; gift of the Ruskin Family, Calgary, in memory of George Ruskin, 1994. Accession number: 1994.163

Iain Baxter (Canadian, b. 1936), **B.C. Landscape**, 1965, painted vacuformed plastic, 32 x 37.5 inches. The University of Lethbridge Art Collections; gift of Mr. Stanley Shapson, 1992. Accession number: 1992.278

Iain Baxter (Canadian, b. 1936), **Seat of Power**, 1990, expanded metal box, padded seating, stuffed animals, text 72 x 24 x 24 inches. The University of Lethbridge Art Collections; gift of the Ruskin Family, Calgary, in memory of George Ruskin, 1994. Accession number: 1994.164

Peter Blake (British, b. 1932), **Pin Up Girl**, 1962, oil on board, 19 x 13.62 inches panel size. The University of Lethbridge Art Collections; purchase 1988 as a result of the British Gift (anonymous donor). Accession number: 1988.275

David Buchan (Canadian, 1950-1994), 2 Photomurals: **"Modern Fashions - Men Like You Like Semantic T-shirts,"** 1979 and **"Modern Fashions - Killing Time,"** 1979, 60.25 x 46.87 inches (153 x 119 cm) each. The University of Lethbridge Art Collections; gift of anonymous donor, Toronto, 1988. Accession numbers: 1988.253; 1988.254

Dennis Burton (Canadian, b. 1933), **Death of the Order of the Garter**, 1967, oil on canvas, 40 x 40 inches. The University of Lethbridge Art Collections; purchase 1986 with funds provided by the Province of Alberta Endowment Fund. Accession number: 1986.071

Patrick Caulfield (British, b. 1936), **O Helen, I Roam My Room**, 1970, gouache on paper, 17.25 x 14.75 inches. The University of Lethbridge Art Collections; purchase 1983 with funds provided by the Alberta 1980s Endowment Fund. Accession number: 1983.469

Patrick Caulfield (British, b. 1936), **Still Life on Checked Table**, 1968, oil on canvas, 36 x 60 inches. The University of Lethbridge Art Collections; purchase 1984 with funds provided by the Alberta 1980s Endowment Fund as a result of the British Gift (anonymous donor). Accession number: 1984.052

Chuck Close (American, b. 1940), **Marta/Fingerprint**, 1986, direct gravure on copper, 54.125 x 40.375 inches. The University of Lethbridge Art Collections; gift of Gary M. Gray, 1993. Accession number: 1993.443

Tony Cragg (British, b. 1949), **Shoe**, 1983, black plastic found objects, shoe, 7 x 11 ft. installed. The University of Lethbridge Art Collections; purchase 1988 with funds provided from the Alberta Advanced Education Endowment and Incentive Fund. Accession number: 1988.091

Michael Craig-Martin (British, b. 1941), **Light Bulb**, c. 1983, painted metal, 29 x 16.25 inches. The University of Lethbridge

Art Collections; purchase 1988 as a result of an anonymous donation (Inuit Gift). Accession number: 1988.282

Chris Cran (Canadian, b. 1949), ***Self-Portrait Just Two Maos Down From Some Guy With a Goddamned Tea Cosy on His Head***, 1985, oil on canvas, 66.12 x 108.25 inches (168 x 275 cm). The University of Lethbridge Art Collections; on extended loan from the collection of Douglas M. and Teresa Hilland. Accession number: Loan

Chris Cran (Canadian, b. 1949), ***Large Pink Laughing Man***, 1991, oil and acrylic on canvas, 274 x 183 cm. The University of Lethbridge Art Collections; gift of the artist, 1992. Accession number: 1992.335

Greg Curnoe (Canadian, 1936-1992), ***#1 Iron, 1ˢᵗ Hole Thames Valley Golf Course with Delaunay Sky***, 1968-7, acrylic on panel, 8 x 8 feet. The University of Lethbridge Art Collections; purchase 1985. Accession number: 1985.133

Greg Curnoe (Canadian, 1936-1992), ***Lacrosse***, August 19, 1962, collage on cardboard, 18 x 14 inches. The University of Lethbridge Art Collections; gift of the artist, 1991. Accession number: 1992.451

Greg Curnoe (Canadian, 1936-1992), ***Toronto Transfer/Labatt's Label***, 1962, collage on printed paper, 18 x 14 inches. The University of Lethbridge Art Collections; gift of the artist, 1991. Accession number: 1992.452

Jim Dine (American, b. 1936), ***Palette #4 (Joan)***, 1964, mixed media & collage, 29 x 23 inches. The University of Lethbridge Art Collections; purchase 1988 with funds provided by the Alberta Advanced Education Endowment and Incentive Fund. Accession number: 1988.062

Jim Dine (American, b. 1936), ***Hand Colored Viennese Heart II***, 1987-90, screenprint with intaglio and acrylic paint, 18/40, 47 x 36 inches. The University of Lethbridge Art Collections; gift of an anonymous donor, 1992. Accession number: 1992.207

Jim Dine (American, b. 1936), ***The Picture of Dorian Gray***, 1968, limited edition book, 77/200, 18 x 12 1/2 inches (18 x 25 inches opened). The University of Lethbridge Art Collections; gift of Hon. John Roberts, Toronto, 1989. Accession number: 1989.092

Jim Dine (American, b. 1936), ***Colorful Venus and Neptune***, 1992, Color woodcut (diptych), 3/11, Panel 1: 67.12 x 37.12 inches; panel 2: 62 x 41.75 inches. The University of Lethbridge Art Collections; gift of an anonymous donor, 1998. Accession number: 1998.44

Jim Dine (American, b. 1936), ***Pitchfork***, 1984, painted bronze, 1/6, 16 x 15.5 x 24 inches, The University of Lethbridge Art Collections; gift of an anonymous donor, 1998. Accession number: 1998.4

Gathie Falk (Canadian, b. 1928), ***Picnic with Red Watermelon #1***, 1976, ceramic, 11 3/4 x 18 1/2 x 13 1/2 inches. The University of Lethbridge Art Collections; purchase 1997. Accession number: 1997.4

David Gilhooly (American, b. 1943), ***Chocomallow***, 1972; ***Yellow Oreo; Lemon-filled Bread***, 1974; ***Small Loaf***, 1971; ***Steak***, 1973; ***Chocolate Covered Frog Cup-cake***, 1978, ceramic, 7 x 8 x 28 inches (plexi-covered display case with 6 ceramic sculptures). The University of Lethbridge Art Collections; gift of J. Spalding, 1985. Accession numbers: 1985.101-1985.106

Richard Hamilton (British, b. 1922), ***Interior***, 1964, screenprint, 24/50, 24 1/4 x 27 7/16 inches. The University of Lethbridge Art Collections; purchase 1997. Accession number: 1997.1

David Hockney (British, b. 1937), ***A Rake's Progress***, 1961-63, series of 16 etchings, 23/50, 19 1/2 x 24 3/8 inches. The University of Lethbridge Art Collections; purchase 1984 with funds provided by the Alberta 1980s Endowment Fund.

Accession number: 1984.023-1984.038

Jenny Holzer (American, b. 1951), Selections from *Truisms*, 1985, LED sign with red diodes, 4/5, 6 1/2 x 121 1/2 x 4 inches. The University of Lethbridge Art Collections; purchase 1988 with funds provided by the Alberta Advanced Education Endowment and Incentive Fund. Accession number: 1988.124

Robert Indiana (American, b. 1928), *Eternal Hexagon*, 1964, screenprint, 51/500, 24 x 20 inches. The University of Lethbridge Art Collections; British Gift 1983 (donor anonymous). Accession number: 1983.218

Allen Jones (British, b. 1937), *Copied From a Higher-Priced Original*, 1974, acrylic on canvas, 60 x 60 inches. The University of Lethbridge Art Collections; gift of an anonymous donor, 1992. Accession number: 1992.205

Allen Jones (British, b. 1937), *Strongman*, 1988, painted steel, 79.25 x 20 x 59 inches. The University of Lethbridge Art Collections; gift of an anonymous donor, 1998. Accession number: 1998.12

Allen Jones (British, b. 1937), *Clasp*, 1990, watercolor on paper, 30 x 22 inches. The University of Lethbridge Art Collections; gift of an anonymous donor, 1998. Accession number: 1998.18

Allen Jones (British, b. 1937), *Brahms Clarinet Quintet*, 1984, watercolor on paper, 27 x 40 inches. The University of Lethbridge Art Collections; gift of an anonymous donor, 1998. Accession number: 1998.19

Alex Katz (American, b. 1927), *Red Band*, 1979, screenprint 55/60, 55 x 36 inches. The University of Lethbridge Art Collections; purchase 1983. Accession Number: 1983.420

R. B. Kitaj (American, b. 1932), *Pogany*, 1966, screenprint, 56/70, 26 7/8 x 40 1/4 inches. The University of Lethbridge Art Collections; British Gift 1983 (donor anonymous). Accession number: 1983.229

John Latham (British, b. 1921), *Untitled*, 2/12/1958, mixed media on board, 18.5 x 17.5 x 7 inches. The University of Lethbridge Art Collections; purchase 1990. Accession number: 1990.029

Roy Lichtenstein (American, 1923-1997), *Sandwich and Soda (Lunch Counter)*, 1964, from the Wadsworth Atheneum portfolio: "X + X" - Ten Works by Ten Painters, color screenprint on acetate, 51/500, 20 x 24 inches. The University of Lethbridge Art Collections; British Gift 1983 (donor anonymous). Accession number: 1983.256

Attila Richard Lukacs (Canadian, b. 1962), *The Instilling within the Boy*, 1990, screenprint on nylon, 96/120, 72 x 36 inches. The University of Lethbridge Art Collections; gift of Helen and Joe Lukacs, 1992. Accession number: 1992.407

Bruce McLean (Scottish, b. 1944), *Custom Built*, 1991, monotype on steel, 55 x 55 inches. The University of Lethbridge Art Collections; gift of Miriam Shiell, 1995. Accession number: 1995.113

Claes Oldenburg (American, b. 1925), *Soft Drum Set*, 1960/69, mixed media multiple, 47/200, 10 x 19 x 14 inches. The University of Lethbridge Art Collections; purchase 1986 with funds provided by the Province of Alberta Endowment Fund. Accession number: 1986.151

Eduardo Paolozzi (British, b. 1924), *Who's Afraid of Sugar Pink and Lime Green?*, 1971, screenprint, 86/100, 60 x 44 inches. The University of Lethbridge Art Collections; purchase 1988 with funds provided by the Alberta Advanced Education Endowment and Incentive Fund. Accession number: 1988.052

Eduardo Paolozzi (British, b. 1924), *Avant-Garde*, 1971, screenprint, 20/25, 23 x 30.5 inches. The University of Lethbridge Art Collections; British Gift (donor anonymous), 1983. Accession number: 1983.282

Peter Phillips (British, b. 1939), **Tribal I x 4**, 1962, oil on canvas, 42 x 39 inches. The University of Lethbridge Art Collections; purchase 1988 with funds provided by the Alberta Advanced Education Endowment and Incentive Fund. Accession number: 1988.074

Robert Rauschenberg (American, b. 1925), **Untitled**, 1980, solvent transfer on paper with oil, fabric and paper collage, 31 x 22 3/4 inches. The University of Lethbridge Art Collections; gift of Evelyn Aimis, 1993. Accession number: 1993.305

Robert Rauschenberg (American, b. 1925), **America Mix**, 1983, (4 Prints from a suite of 16), photogravure with chine colle, 20 x 26 inches. The University of Lethbridge Art Collections; gift of Gary M. Gray, 1993. Accession number: 1993.450 (tba).

Robert Rauschenberg (American, b. 1925), **Bamhue** (Japan), 1987, mixed media sculpture, a.p. (ed. 25), 91 x 5 x 10 inches. The University of Lethbridge Art Collections; gift of Dr. and Mrs. David H. Ornstein, 1993. Accession number: 1993.425

James Rosenquist (American b. 1933), **New Oxy**, 1963, color lithograph from **I¢ Life** (edition of 2000, unsigned, 100 signed, published, © 1964, E.W. Kornfeld, Bern), 16 x 22 inches. The Florida State University Museum of Fine Arts. Accession number: 63.10

James Rosenquist (American, b. 1933), **The Kabuki Blushes**, 1986, lithograph/monoprint, 39 x 41 1/2 inches. Collection: Graphicstudio. Printed at Graphicstudio, University of South Florida; photograph courtesy of Graphicstudio.

David Salle (American, b. 1952), **Canfield Hatfield Portfolio**, 1989-90 (1 print from a portfolio of 9), etching/aquatint, 23/60, 24 x 36.4 inches. The University of Lethbridge Art Collections; gift of an anonymous donor, 1992. Accession number: 1992.210 (tba)

George Segal (American, b. 1924), **Naked Girl**, 1978, plaster, 41 1/2 x 28 1/2 x 22 1/2 inches. The University of Lethbridge Art Collections; purchase 1991 as a result of a gift from Dr. Roloff Beny. Accession number: 1991.011

Michael Snow (Canadian, b. 1929), **Drawing Foldage**, 1961, graphite on paper, 39 1/2 x 29 1/2 inches. The University of Lethbridge Art Collections; purchase 1986 with funds provided by the Province of Alberta Endowment Fund. Accession number: 1986.073

Wayne Thiebaud (American, b. 1920), **Four Cakes**, 1979, etching/aquatint, 43/50, 22 1/2 x 29 3/4 inches (paper). The University of Lethbridge Art Collections; purchase 1988 with funds provided by the Alberta Advanced Education Endowment and Incentive Fund. Accession number: 1988.020

Joe Tilson (British, b. 1928), **Martin Luther King**, 1969, relief, screen and oil on canvas and wood, 176.7 cm x 125.7 cm. On loan from the Appleton Museum of Art, Ocala, Florida.

Joe Tilson (British, b. 1928), **Two Wristwatches**, 1965, vacuum shaped plastic with flocking, 5/5 27 x 29 x 3 1/2 inches. The University of Lethbridge Art Collections; British Gift 1983 (anonymous donor). Accession Number: 1983.319

Tony Urquhart (Canadian, b. 1934), **A Box of Smiles**, 1961, oil wash and collage on board, 28 x 44 inches. The University of Lethbridge Art Collections; gift of the artist, 1994. Accession number: 1994.675

Andy Warhol (American, 1928-1987), **Birmingham Race Riot**, 1964, screenprint, 51/500, 20 x 24 inches. The University of Lethbridge Art Collections; British Gift 1983 (donor anonymous). Accession number: 1983.359

Andy Warhol (American, 1928-1987), **Tomato-Beef Noodle O's**, 1969, screenprint, from the portfolio of ten

screenprints: **Campbell's Soup II**, 35 x 23 inches. The University of Lethbridge Art Collections; British Gift 1983 (donor anonymous). Accession number: 1983.357

Andy Warhol (American, 1928-1987), **Jackie III**, 1965, color screenprint from **11 Pop Artists**, volume III, 59/200, 40 x 30 inches. The University of Lethbridge Art Collections; purchase 1989 with matching funds provided by the Alberta 1980s Endowment Fund. Accession number: 1989.024

Andy Warhol (American, 1928-1987), **Mao**, 1973, acrylic and silkscreen on canvas, 12 x 10 inches. The University of Lethbridge Art Collections; purchase 1984 with funds provided by the Alberta 1980s Endowment Fund as a result of the British Gift (anonymous donor). Accession number: 1984.022

Andy Warhol (American, 1928-1987), **Vote McGovern**, 1972, screenprint, ed. 250, 42 x 42 inches. The University of Lethbridge Art Collections; purchase 1982. Accession number: 1982.030

Andy Warhol (American, 1928-1987), **Wayne Gretzky 99**, 1982, screenprint, 133/300, 39 1/2 x 31 1/4 inches. The University of Lethbridge Art Collections; gift of Mr. J. Derek Cook, Richmond, B.C., 1986. Accession number: 1986.227

Andy Warhol (American, 1928-1987), **Wayne Gretzky 99**, 1984, screenprint, 29/46, 39 1/2 x 31 1/4 inches. The University of Lethbridge Art Collections; gift of Mr. J. Perron, 1989. Accession number: 1989.295

Tom Wesselmann (American, b. 1931), **Great American Nude**, 1967, mixed media on paper, 7 x 9 inches. The University of Lethbridge Art Collections; purchase 1988 as a result of a gift from Mr. J. Derek Cooke, Richmond, B.C., 1986. Accession number: 1988.281

Tom Wesselmann (American, b. 1931), **Nude (for Sedfre)**, 1969, screenprint, 4/100, 23 x 29 inches. The University of Lethbridge Art Collections; purchase 1997. Accession number: 1997.3

Joyce Wieland (Canadian, 1931-1998), **Cooling Room No. 1**, 1964, painted construction in plexiglas box 38 x 31 1/2 x 11 1/2 inches. The University of Lethbridge Art Collections; gift of Vivian and David Campbell, Toronto, 1989. Accession number: 1989.036

Joyce Wieland (Canadian, 1931-1998), **Untitled (sinking liner)**, c. 1963, oil on canvas, 32 x 24 1/8 inches. The University of Lethbridge Art Collections; purchase 1985 with funds provided by the Province of Alberta Endowment Fund. Accession number: 1985.028

Joyce Wieland (Canadian, 1931-1998), **Young Woman's Blues**, 1964, painted wood construction with objects, 21 x 12.5 x 8.75 inches. The University of Lethbridge Art Collections; purchase 1986 with funds provided by the Province of Alberta Endowment Fund. Accession number: 1986.072

John Will (American, b. 1939; lives Calgary, Alberta, Canada), **Untitled (Proudly Canadian)**, 1986, oil, polaroids, bumper sticker on canvas, 86 x 69 inches. The University of Lethbridge Art Collections; gift of the artist, 1995. Accession number: 1995.207

John Will (American, b. 1939; lives Calgary, Alberta, Canada), **Untitled (God Bless the USA)**, 1986, oil, polaroids, bumper sticker on canvas, 86 x 69 inches. The University of Lethbridge Art Collections; gift of the artist, 1995. Accession number: 1995.208

Russ Yuristy (Canadian, b. 1936), **Old Style Pilsner Beer**, 1975, ceramic sculpture, 15 x 10 inches. The University of Lethbridge Art Collections; purchased 1986 with funds provided by the Province of Alberta Endowment Fund. Accession Number: 1986.069